St. Petersburg
Florida

St. Petersburg Florida

A VISUAL HISTORY

A. Wynelle Deese

Charleston London

History
PRESS

Published by The History Press
Charleston, SC 29403
www.historypress.net

Cover Image: The Hotel Rolyat as it looked when it opened in 1926. The hotel was created by Jack Taylor to show an image of high-class luxury.

First published 2006

Manufactured in the United Kingdom

ISBN 1.59629.095.1

Library of Congress Cataloging-in-Publication Data

Deese, A. Wynelle (Alma Wynelle)
St. Petersburg, Florida : a visual history / A. Wynelle Deese.
p. cm.
ISBN 1-59629-095-1 (alk. paper)
1. Saint Petersburg (Fla.)--History--Pictorial works. 2. Postcards
--Florida--Saint Petersburg. 3. Saint Petersburg (Fla.)--Buildings,
structures, etc.--Pictorial works. 4. Saint Petersburg (Fla.)--Social
life and customs--Pictorial works. 5. Historic buildings--Florida
--Saint Petersburg--Pictorial works. I. Title.
F319.S24D44 2006
975.9'63--dc22

2006010693

Notice: The information in this book is true and complete to the best of our knowledge. It is offered without guarantee on the part of the author or The History Press. The author and The History Press disclaim all liability in connection with the use of this book.

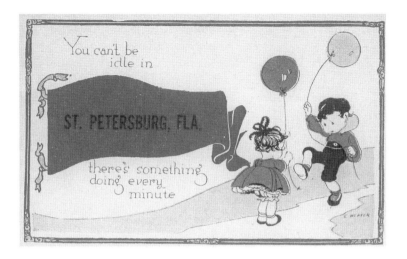

*T*his cute artist-signed postcard by E. Weaver is different from the other postcards used in this book. The artist is known for producing only comic postcards. Since there were thousands of signed artists who designed postcards, only the most significant ones are known and E. Weaver is such a person. Such freelance artists produced postcard designs that established them on their own merits and this delightful postcard is such an example. E. Weaver was an American artist with worldwide recognition.

The other signed artist in this book, E.G. Barnhill, started as a local St. Petersburg photographer who hand painted his view postcards and had a more limited appeal as a artist. All the other postcards used in this book are unsigned and would be designated as view postcards by postcard collectors.

This postcard is part of a series titled, "Sentimental kids, #2325." The St. Petersburg, Florida, name was added by a local seller.

The back of the postcard shows that it was sent December 31, 1922, from St. Petersburg. The message reads, "Dear Friend, A Happy New Year to you and many of them without sorrow is the wish of uncle."

The back of the postcard had another historical distinction: it had an 1922 Christmas seal issued by the National Tuberculosis Association showing a mother and child, a reminder of one important medical problem of that time.

This one postcard has many interpretations for current readers. The fact that it was connected to St. Petersburg was incidental but it reflects many issues outside of St. Petersburg. That is part of the charm that old postcards hold for collectors.

Dedicated to my husband, Judge J.W. Deese, after celebrating forty years together, ten of which were in St. Petersburg, Florida.

Contents

Acknowledgements 11
Introduction 13

Banks and Businesses 17
Beaches, Benches and Birds 34
Bygone Hotels and Restaurants 45
Fishing, Foliage and Fruit 58
Local People and Photographs 72
Military, Movies and Music 83
Real Estate Developments and Agents 100
Recreation, Shopping and Sports 115
Tourist Attractions and Services 130
Trains, Trolleys and Transportation 146

Bibliography 159

Acknowledgements

S pecial thanks need to be given to Ann Louise Wikoff, archivist at the St. Petersburg Museum of History and other members of that organization for their help with researching the history of St. Petersburg. Without the dedication of those people, that history would not be what it is today.

Introduction

O h, no, not another St Petersburg history book," has been a typical reaction when telling someone of writing this history. That reaction was not viewed as negative but rather understandable, since there are many outstanding histories already written about St. Petersburg. There is a general feeling that history about St. Petersburg has been maximized or saturated. Some of those outstanding histories are listed in the bibliography and I would encourage anyone to read them.

Yet I would disagree that the history of St. Petersburg has reached a saturation point. Instead, more variation within its history needs to be explored. Most histories of St. Petersburg have followed chronological progressions, such as Mayor Baker's book, *Mangroves to Major League*. Photos or postcard pictures have often been shown along with the evolution of the city.

The city has published postcards over the years in voluminous proportions. A wealth of history has been captured on those postcards. Many of those postcards have survived, providing beautiful historical pictures that many other cities today would envy.

There are several untapped uses of old St. Petersburg postcards. George and Dorothy Miller, postcard collectors and writers of *Picture Postcards in the United States 1893-1918*, have identified at least four uses of old postcards. The first and the most common use of old postcards is that of showing postcards of buildings and structures of the past, as Spencer has done in his book *St. Petersburg in Vintage Postcards*. He showed views of previous structures that may not be realized without the documentation from old postcards.

A second use of old postcards is to compare past structures with current structures at the same location, as I did in my first St. Petersburg book, *St. Petersburg, Now and Then*. However, that book could only focus on the downtown part of St. Petersburg while surrounding areas were excluded due to the planned limitations of the book.

A third use of old postcards has been in the recording of various early ethnic groups such as Mellinger and Alloula have done. Mellinger documented African Americans as depicted in

postcards with social meanings of the time. Alloula studied the French-Algerian women as they were pictured on postcards and evaluated the social structures of the time.

A fourth use of old postcards has been identified as social history similar to what Dr. Bogdan has done in many of his articles and books. He found that postcards depicting common people's interest are more reflective of social attitudes at the time.

Social history based on old postcards will emphasize the common interests of the people rather than reflecting great people or outstanding events. Often common events and simple subjects are ignored. When one reviews a large collection of St. Petersburg postcards as I have done, there are a lot of what is called common postcards, reflecting local activities. While old postcards can always add interest to any historical interpretation, a social history focus based on old postcards will reflect the general interests of the population rather than of the historian or writer. Social history from old postcards can offer a different historical perspective on St. Petersburg.

While there have been some books looking at social history from a historical perspective and such is a legitimate method, a social history of St. Petersburg using old postcards as an indicator of common local interests has not been done. Since St. Petersburg postcards were very prolifically produced, the postcards that have survived into the twenty-first century must have had some personal appeal to those who saved them.

When postcards first went on sale in the United States in 1893, they were an instant success. Initially, they were valued as commodity souvenirs, but they later assumed a prominent place in middle and upper class life as every parlor had its postcard album based on the person's interests. In 1906, the zenith of the postcard era, over several hundred million postcards were sold. While some American cities had very limited numbers of early postcards and few pictures of their early buildings, St. Petersburg has always had many postcards.

I have done four previous old postcard books about specific locations, one of Lexington, Kentucky; of St. Petersburg, Florida; of the Bluegrass area (sixteen counties) of Kentucky; and of the state of Mississippi. When searching for old postcards specific to each area, the Mississippi postcards were scarcest, even though I was searching for postcards of a whole state. The Kentucky postcards were next limited in quantity while St. Petersburg, Florida, was always the most prolific, albeit just one city. While St. Petersburg was appealing to the tourist trade by publishing postcards as early as 1905, other locations such as Mississippi and Kentucky produced fewer numbers of postcards and even fewer survived.

Postcards are representative of popular culture of a specific time. Today, these hundred-year old postcards are increasingly highly valued collectors' items sold at flea markets and antique shows around the country. They are increasingly gaining scholarly attention. Part of that scholarly attention is related to looking at the culture and social history that is revealed about a particular area, in this case, St. Petersburg.

For this book, twenty-five topics were created from the greatest number of common postcards related to St. Petersburg. Those topics were arranged in alphabetical order and grouped into ten chapters. The best postcards were picked for the topics and other rare postcards were added to show variety within the topics. The topics were researched at the St. Petersburg Historical Museum for specific facts about people and events related to the topics.

I have over 1,000 old St. Petersburg postcards and selected around 200 for the first book. Another 160 postcards were used in this second book. Any duplication of postcards with the first book was avoided in this second book of postcards except when a needed image was not attainable elsewhere.

One obvious problem that develops from using old postcards to understand any social history is that most postcards used in this book were published around 1905 to 1950 and limited to that time frame. St. Petersburg has grown a great deal since 1950. I will try to compensate by including growth changes up through the year 2000.

Magnanimous postcard publication decreased after the 1950s, partly due to a lack of interest, change in advertising techniques and change in technologies. While social history can be determined from the early postcards, the absence of social history cannot be concluded after the 1950s, but rather, the methods of determining social history have changed and are now beyond the scope of this book. The purpose of this book is to show that social history is available from the old postcards and did influence a specific time period in the history of St. Petersburg.

This book was fun for me to compile and research. I hope that the readers will enjoy it as much as I have.

Banks and Businesses

S t. Petersburg was a sleepy town of 1,572 people in 1900. As more people moved to the early city, an economic basis in the form of banks became necessary for the development of business and commerce. The first bank in the city, the St. Petersburg State Bank, a frame building, was opened in 1893 on the southwest corner of Fourth Street and Central. The bank's president, John A. Bishop, invested the depositors' money in a Pasco County phosphate mine. The bank collapsed by 1902, representing a large part of St. Petersburg's wealth. It was not until 1914 that the original depositors received twenty-five cents on each dollar.

A second bank was established in October 3, 1902, under the name of West Coast Bank. A lot on the southeast corner of Second and Central was purchased and a three-story brick building was erected. In 1905, it was renamed the First National Bank, as it was the first national bank in this area.

Another postcard circa 1910 shows the interior view of the First National Bank with two spittoons prominently placed around the teller windows. A possible boardroom can be viewed on the right and on the left is an area identified as "ladies alcove." The properness of a "ladies alcove" was probably more of a regional tradition of specific individuals rather than it being a Florida tradition. In these early days, the citizens of St. Petersburg came from many different geographical areas and they often brought with them their own traditions.

The vice-president of the First National Bank had an elegant Queen Anne-style residence built at 256 Beach Drive in 1915. Chancey W. Springstead had come to St. Petersburg to first grow citrus. Then he tried banking and later, real estate development. He created the Spring Hill subdivision between Fourth and Ninth Streets North near Crescent Lake. He reflected the various business opportunities that were available to the early settlers.

A third bank and second National Bank in St. Petersburg, the Central National Bank, opened in 1912 on the southwest corner of Fourth and Central. This location had been the original location of the first bank in the city but this third bank building was a three-story brick building with metal-railed balconies and tile-roofed overhangs. Still located at Central

Avenue and Fourth Street, it claimed to be "the financial center" with "profits over one million dollars."

A fourth bank, American Bank & Trust Company, erected in 1913 on the south side of Central Avenue between Third and Fourth Streets, was a two-story structure with solid granite Doric columns. The American Bank & Trust Company was one of three banks listed in the 1916 St. Petersburg city directory.

A bank not listed in the 1916 city directory, but opened in 1913, was the Florida Bank and Trust. It was built to be fire and burglarproof, but it did not survive the recession of the local economy. There was an inside view of that same Florida Bank and Trust on an old postcard but the inside was very bare compared to the previous inside views. The fact that postcards of this bank survived when the bank did not survive more than three years is a mystery.

By 1930, there were six surviving banks with each having new identifications in the city directory. The same American Bank & Trust at 338-340 Central and a new Fidelity Bank and Trust at Central and Seventh Street were both identified as savings banks. The same Central National Bank and Trust at Central and Fourth Street and same First National at 480 Central were still national banks. Two newer banks, the Ninth Street Bank & Trust at 871 Central Avenue and First Security at Ninth Street North, were state banks.

The Ninth Street Bank & Trust at 871 was located where an earlier Klutts Grocery had been. The bank had been opened in 1921, reorganized into the Crosstown Bank in 1925 and became the Union Bank in 1930.

The national economic depression had a devastating affect upon the economy and banks of St. Petersburg. In 1931, 40,425 citizens were listed in St. Petersburg with an average income of $203 each. By 1931-32, every bank in the city was forced to close and depositors were forced to accept a fraction of their actual holdings. Difficult times came to the business community of St. Petersburg.

The introduction of an FDIC savings bank in 1933 in St. Petersburg under the name of First Federal Savings and Loan Association was part of a national attempt to revive the economy. Individuals such as Raleigh W. Greene as president and Oscar R. Kreutz as chairman led the organization for many years. While that organization did change as it grew, it was a stable financial institution that continued for many years in St. Petersburg. It became one of the South's largest savings and loans for years.

In September 1933, First Federal's door was opened for business on the fifth floor of the Florida Theatre building in downtown St. Petersburg, but few were willing to venture how long it would last. It was not until October of that year that a mortgage loan was made in the amount of $750 for a small bungalow at 4100 Haines Road. After exhaustive investigation of the purchasers, Frank E. and Minnie M. Allen obtained a mortgage at 6 percent interest and had a term of one hundred months. In 1937, that mortgage was paid off as the Allens sold their property for $3,500. First Federal was proud of their participation in that transaction.

In 1935, First Federal took over the ground floor of the Equitable Building, a landmark building at Fourth Street and Central Avenue. First Federal continued to grow by providing mortgages to the construction industry in home building.

In 1937, R.W. Greene sent out letters to potential buyers encouraging them to build their own homes. He stated that costs were lower during the summer months as money was plentiful and interest rates were easy. He included a one-floor house plan with three bedrooms, two bathrooms and two-car garage for $8,200 with the letters that he sent out to potential customers. He had another two-story plan with three bedrooms, a study, three bathrooms and two-car garage for $13,500. The letters emphasized that if First Federal financed the home they would give expert supervision of the work and assured them of a quality home. It was a wonderful opportunity for new families to buy a home in the city as it helped the city to grow. Local individuals such as realtor John B. Green and Odette Patterson as public relations officer added their own special talents to the First Federal Savings organization.

In 1949, First Federal opened its first branch office, symbolizing the drive-in part of banking. The First Federal Savings and Loan Association grew into one of the South's largest savings and loans. By the 1950s, additional branches were established including one on the Gulf beaches, indicating how First Federal had grown and how the Gulf beaches had gained recognition as a financial resource.

By the middle of the 1950s, the First National Bank had moved from its previous location, taking over what had been the Central National Bank building. This First National Bank claimed to be a member of the FDIC and Federal Reserve System with a drive-in branch facing First Avenue and Fourth Street.

By the 1960s, the only remaining early banks included First National Bank at 400 Central and Fourth Street, the Florida National Bank at 474 Central and Union Trust Company at 871 Central Avenue at Ninth Street, with several other new banks. These same three banks continued into the 1970s. The Union Trust Bank was changed to the Landmark Bank in 1980 and by the 1990s none of these banks still existed with the same names, all having been reorganized.

The First National Bank facility was reorganized into the Wachovia Bank around the year 2000. The building's outside appearance has changed with modern grillwork over the original building. As we can observe, reorganizations and name changes of St. Petersburg banks have been a part of the past as well as into the present. As most bank changes were related to economic changes of booms and busts within the city and in the country, other commerce and business continued to grow in the city.

The First Federal Savings and Loan Association in 1990 changed its name to Florida Savings and Loan, making it available to a larger area than St. Petersburg. By 1991, the federal government seized the financially troubled St. Petersburg-based Florida Savings and Loan Association after a brief tenure as a Florida Savings and Loan. It had been one of the primary corporate employers and leaders of the city since 1933. Its branches and deposits were sold to North Carolina's First Union Corp. Again, residents of St. Petersburg faced another banking disappointment. As economic factors changed with individuals, the impact was often felt but others continued to come as tourists or residents.

When St. Petersburg's original business structures were built around Ninth Street and Central Avenue, they were mostly constructed from wood. There was at least one concrete two-story building in 1909, the Klutts and Bradshaw Grocery, at Central and Ninth Street.

Mary Klutts wrote on a postcard in 1909 that they lived upstairs over the grocery and Central Avenue was paved only up to Ninth Street. John L. and Mary Klutts were listed in the 1912 city directory as operating that grocery store as Klutts and Brothers with a Joseph Klutts at that same location on 871 Central Avenue. The Klutts family was part of the early business world of St. Petersburg.

Many residents and tourists traveled by trolley in St. Petersburg as early as 1905 along Central from the waterfront to Ninth Street, then south on Ninth to Booker Creek. Other trolley routes were added as the city grew until they were replaced with buses in 1936.

As cars become more common, the city's wealth was calculated by the number of Model Ford cars. The first two automobiles were owned by one of the wealthiest men in town, Edwin Tomlinson, who had made his money in mining and oil wells. Automotive services were provided by the Ramm and Williams garages as early as 1910. Paula Ramm, wife of Chester Lewis Williams, a son of St. Petersburg's founder, John C. Williams, operated the Ramm Garage. Two other sons of John C. Williams, King Lewis and J. Mott Williams, operated the Williams Garage for many years.

The city directory of 1935 finds John L. and Mary Klutts operating an automotive service station at Ninth Street and Tangerine Avenue, with their home at 1059 Tangerine Avenue. They had moved out of the downtown area as the city was growing out. One of the last postcards of this chapter has a map that shows Ninth Street and Tangerine Avenue, where their station was located.

As the main businesses of St. Petersburg continued to develop down Central Avenue from Ninth Street toward the waterfront, the most unusual and major commercial development in St. Petersburg started on Ninth Street. James Earl Webb came to St. Petersburg from Tennessee in 1925 to start a cut-rate drug store in 1932. It developed into a complex of seventy-seven businesses called Webb City by 1935. This "World's Largest Drugstore" became one of St. Petersburg's major tourist attractions.

By 1937, Doc Webb had four hundred employees. Webb City became a one-stop shopping center and was bursting at the seams for most of its forty-five years. It was the first convenience store, open seven days a week. Webb City provided anything that customers wanted from cigars, a cafeteria for lunch, a haircut, clothiers, furniture, a beauty facial, gas or tires for a car, house paint, groceries, garden fertilizer, trees or plants, typewriters and more.

Doc Webb was a dashing entrepreneur, a showman extraordinaire who would use any gimmick to attract customers and keep his prices the lowest in town. Webb held circuses on his property, promoted his nationally known "poster girls," advertised a three-cent breakfast and sold sale merchandise directly from railroad cars.

The business of selling cars grew in St. Petersburg as specific dealerships developed. A Ford dealership was first reported in 1930 as the Estes Motor Sales at 231 Third Street Northwest, but most postcards of those early dealerships did not survive for any length of time. Conversely, one such dealership listed in the city directory in 1945 as the Grant Motor Company did have postcards made of their dealership. Mr. W.J. Grant, president of the company located at 405 Ninth Street South, had been a major in the U.S. Army and

returned to St. Petersburg after the war. The Grant Motor Company stayed in that location over twenty years.

By 1960, the city directory had identified W.J. Grant as president of the Grant Motor Company and William J. Grant as vice-president. The company was still at 449 Ninth Street South on that date, but another location was identified at Park Boulevard and Forty-fourth Street. After 1965, the Grant Motor Company had left Ninth Street South and was symbolic of businesses starting to migrate out of downtown St. Petersburg.

The city began to grow out into the county, instead of just along Central Avenue, by the 1960s. While the city grew to 209,000 citizens with an average income of $4,597 by 1966, the number of residents had increased to 216,000 and the average income of $6,646 over the next four years. Instead of businesses developing around Central Avenue, shoppers begin to flock to newer malls. A major retail project completed in 1972, known as Central Plaza, shifted the shopping population away from the city's downtown core. At that time, another $30 million sprawling retail empire called Tyrone Mall covered ten city blocks, employing 1,200 people and attracting an average of 60,000 customers a day. Downtown businesses were declining, a reverse since the beginning of the city.

Webb City became another quirky and quaint St. Petersburg memory. Webb City went out of business in 1979 and the buildings were demolished in 1984. Doc Webb died and his will was executed in 1982 by the Florida National Bank, totaling over $1 million. He left $50,000 to the Senior Citizens Center of St. Petersburg and money to his son and daughter; not bad for someone who claimed to have the cheapest prices in town. A picture of the senior citizens center that he contributed to can be seen in chapter eight.

Business continued to grow out into the suburbs. Many new shopping centers were drawing new and old businesses. Downtown St. Petersburg businesses became dead. The following years saw efforts to bring new life to downtown St. Petersburg with various degrees of successes and failures. The local leaders set out to change the city's image from an elderly retirement haven to a younger, more vibrant center. Those struggles redefined and rebuilt the downtown.

As the era progressed toward the end of the twentieth century, St. Petersburg's downtown business turned more positive. The downtown became a center for attracting museums, performing arts centers and galleries. Major upscale condominium projects were underway as old renovated and new office buildings attracted more businesses. The long-sought entertainment and retail center fought for by local developers was beginning to rise by the beginning of the twenty-first century.

In 1999, a musical production of *Webb City* was developed for a yearlong celebration of Pinellas County's millennium. It highlighted Webb's St. Petersburg career as head of a St. Petersburg landmark that began in 1925 and lasted fifty-four years. While the production was a social phenomenon unique to St. Petersburg, it became significant for the county and the state of Florida. It showed the impact that Webb's business had upon the town of St. Petersburg while recalling that history in music. *Webb City* showed how important business was to the development of a city.

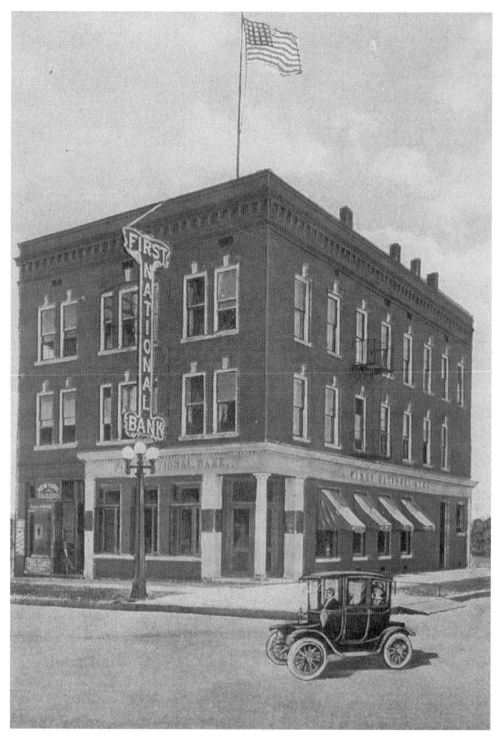

An early picture of the First National Bank, located at this time at the southeast corner of Second Street and Central. Notice the old car and the barbershop. The displayed flag was typical of the patriotic spirit that was part of the city.

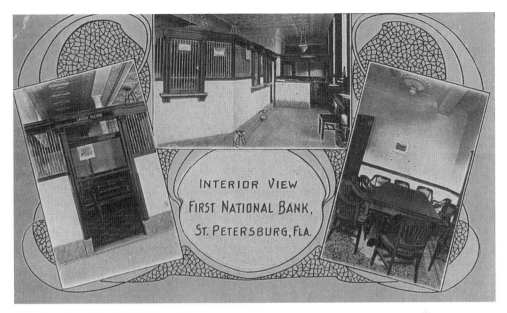

An inside view of the First National Bank.

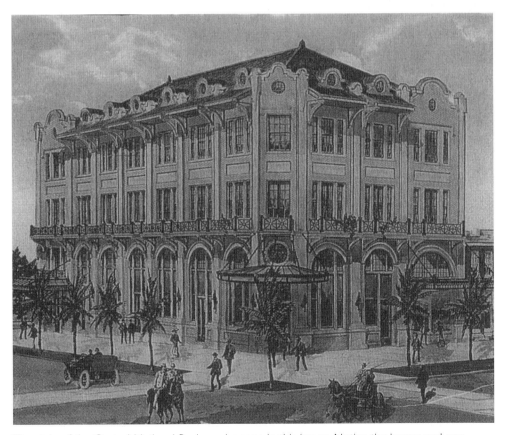

The style of the Central National Bank can be seen in this image. Notice the horses and cars.

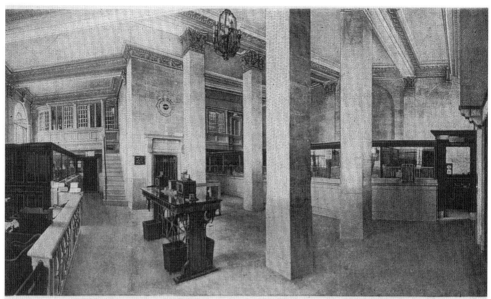

INTERIOR CENTRAL NATIONAL BANK AND TRUST CO., ST. PETERSBURG, FLA.

The interior of the Central National Bank and Trust Company.

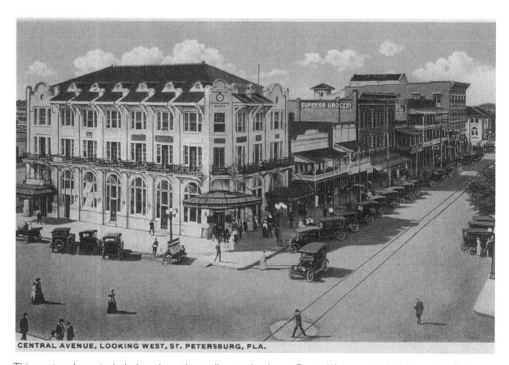

CENTRAL AVENUE, LOOKING WEST, ST. PETERSBURG, FLA.

This postcard was included to show the trolley tracks down Central Avenue. It also shows the First National Bank/Central National Bank building in a 1920s postcard before the Pheil Hotel replaced buildings around the Superior Grocery in this view. The Poinsettia Hotel can be seen with two balconies nearer to Fifth Street.

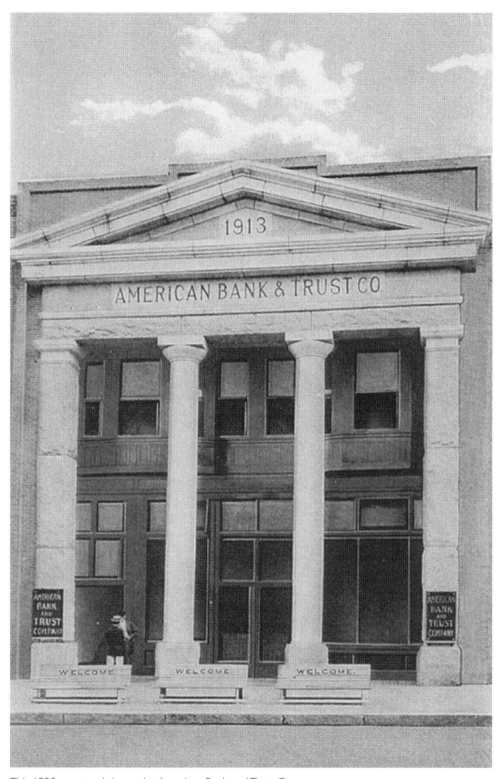

This 1920s postcard shows the American Bank and Trust Company.

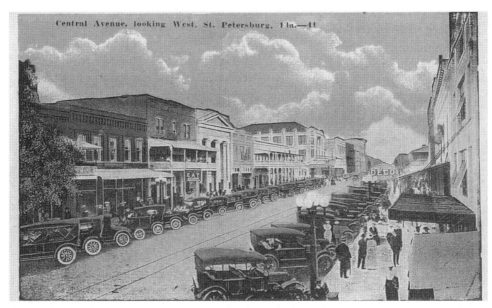

This 1920s postcard of Central Avenue provides another view of the American Bank & Trust Company, located at 342-344 Central Avenue. Central Bank can be seen at the next far corner. Notice the downtown businesses and many cars available by this time. Trolley tracks can be seen in the middle of the street.

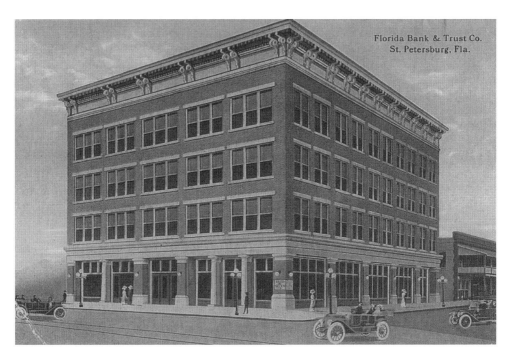

The early Florida Bank and Trust located on the southeast corner of Fifth and Central. Again, the cars are visible and women in white long dresses and hats are present.

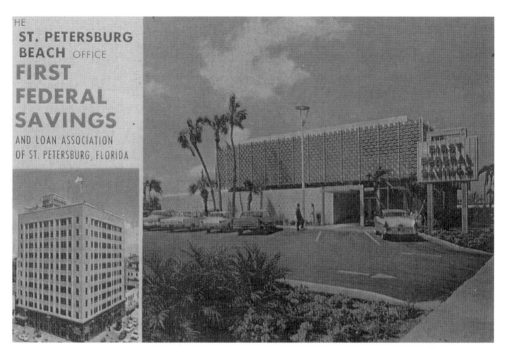

A 1950s postcard shows the First Federal Savings and Loan Association main building located on Central Avenue on the left and their drive-in branch office was emphasized on the right.

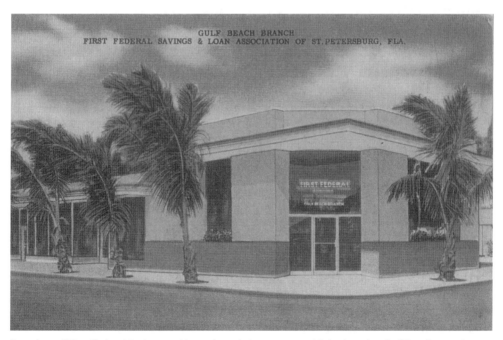

Branches of First Federal Savings and Loan Association were established on the Gulf Beaches as shown in this image. The Gulf Beaches had reached recognition as a financial resource to St. Petersburg.

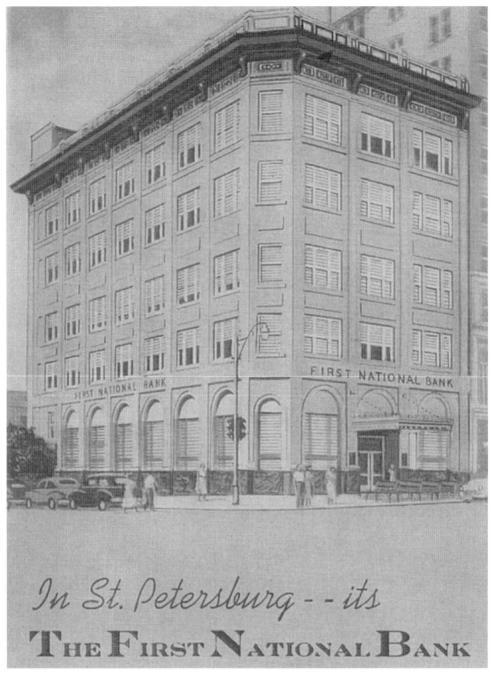

In St. Petersburg - - its

THE FIRST NATIONAL BANK

This 1940s postcard of First National Bank, claiming to be a member of the FDIC and Federal Reserve System, now had a drive-in branch facing First Avenue and Fourth Street. Notice the differences between this building and that same building as Central National Bank earlier, all of the same building but reflecting the changes. The people and cars reflect the time period; notice the unoccupied green benches in front. The large tall building behind the bank is the Pheil Hotel, which opened in 1924.

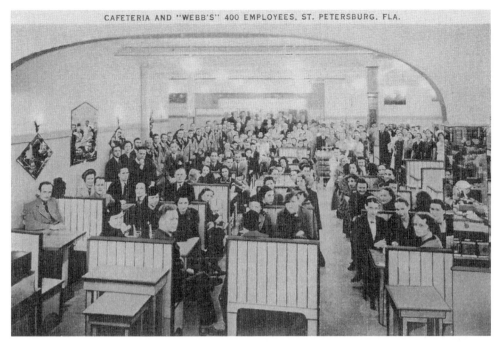

CAFETERIA AND "WEBB'S" 400 EMPLOYEES, ST. PETERSBURG. FLA.

The postcard was made from a newspaper picture with Doc Webb sitting in the front left booth. In this postcard, he is sitting in the second left booth while everything else was the same as published in the newspaper picture.

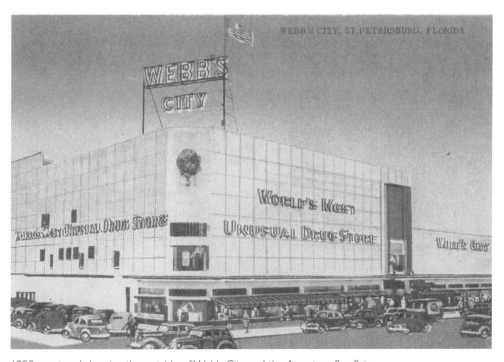

WEBB'S CITY, ST. PETERSBURG, FLORIDA

1950s postcard showing the outside of Webb City and the American flag flying.

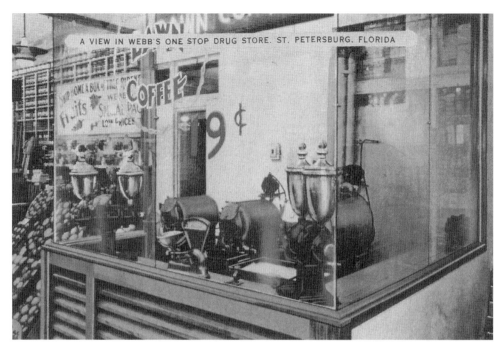

A VIEW IN WEBB'S ONE STOP DRUG STORE. ST. PETERSBURG. FLORIDA

Webb City provided anything that customers wanted from cigars, a cafeteria for lunch, a haircut, clothiers, furniture, a beauty facial, gas or tires for a car, house paint, groceries, garden fertilizer, trees or plants, typewriters and more. This image shows a coffee and fruit display within one of the stores.

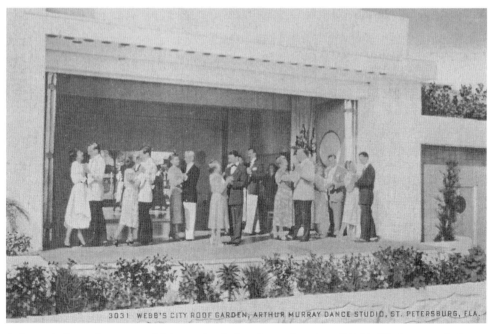

3031 WEBB'S CITY ROOF GARDEN, ARTHUR MURRAY DANCE STUDIO, ST. PETERSBURG, FLA.

A dance studio can be seen on this image, located on the roof garden of Webb City. It was an Arthur Murray Studio.

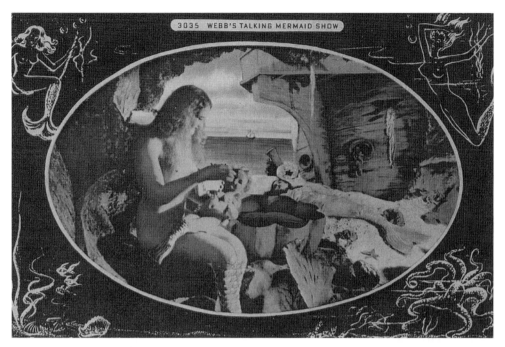

Doc Webb did almost anything to attract customers, including a mermaid display. Some mermaids were store mannequins while others were live women. Customers would put a note in a box next to the mermaids' stand and the mermaids would respond to the questions and talk to the customers.

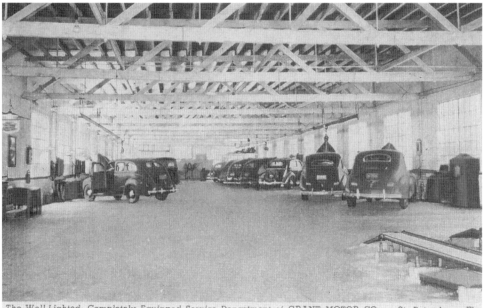

The Well-Lighted, Completely Equipped Service Department of GRANT MOTOR CO. — St. Petersburg, Fla.

A postcard of the 1945-era shows the Grant Motor Company with a well lighted, completely equipped service department. The company was an authorized Ford dealer.

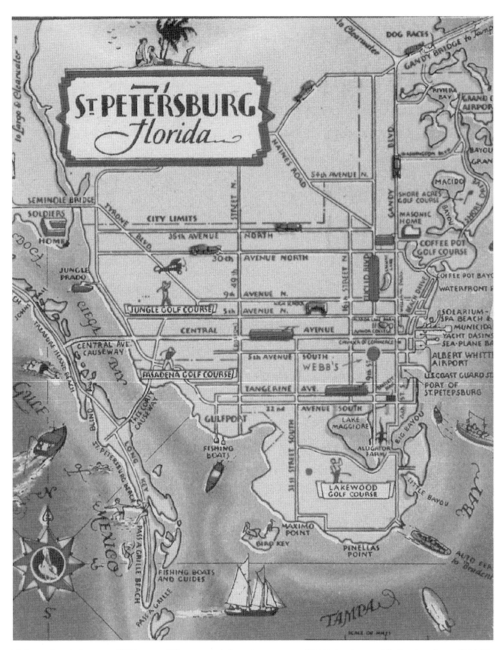

This postcard shows a 1942 map of the general downtown area of St. Petersburg with the location of Webb City identified. The postcard was sent in 1956 so the same downtown picture was used for several years. It does give a good overall and different view of the area. While Tangerine Avenue and Eighteenth Avenue were often used together in St. Petersburg maps as early as 1940, the name of Tangerine Avenue is used singularly in this map. Tangerine Avenue and Ninth was the location of the Klutt's service station and their home. John L. and Mary Klutts continued to operate the service station and live on Tangerine Avenue until 1949. By 1950, Mary Klutts was a widow and William Klutts operated the service station. Later, Tangerine was changed to Eighteenth Avenue.

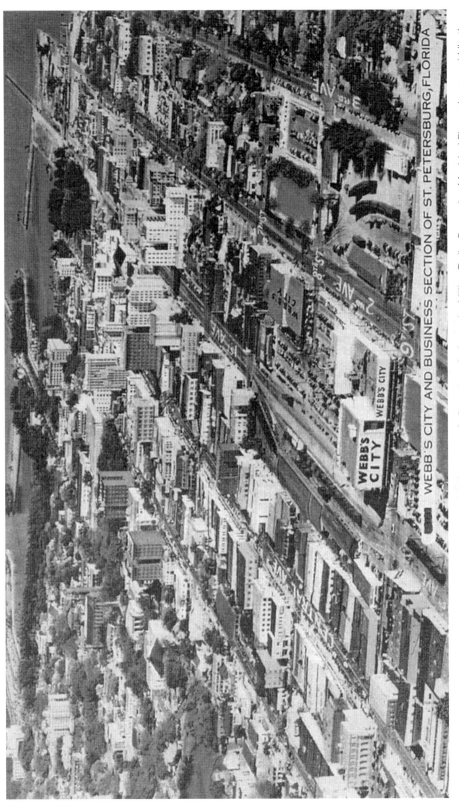

WEBB'S CITY AND BUSINESS SECTION OF ST. PETERSBURG, FLORIDA

A 1950s image shows a view of Webb City and the business area of downtown St. Petersburg. It shows the Million Dollar Recreation Municipal Pier at the top middle, the Albert Whitted Airport on top far right and the Vinoy Hotel on the top far left. First Avenue is identified next to Webb City as Central Avenue is shown parallel to First, Second and Third Avenues South, all giving a good overall picture of the downtown city in the 1940–1950 time frame.

Beaches, Benches and Birds

W hat do the beaches, benches and birds have in common? Obviously, they are part of St. Petersburg's history, displayed on old St. Petersburg postcards and preserved by people who had an interest in them. While beaches and birds have always been a part of the city and can be associated with many other cities, the green benches symbolize only St. Petersburg. The green benches developed and lost out as social attitudes changed within the city. The beaches and birds changed as the population grew. The beaches increased in economic value while the birds continued to be protected by the citizens.

St. Petersburg, being on a peninsula, had access to two types of beaches: the downtown waterfront facing Tampa Bay and the island beaches on the Gulf. As early as 1901, William Straub insisted on public ownership of the undeveloped Tampa Bay waterfront at the time. By July 2, 1902, the Chamber of Commerce adopted a resolution that the waterfront from Second Avenue North to Fifth Avenue North be a public park. A waterfront park was later created paralleling Beach Drive as First Street South had seawalls added from Fifth Avenue North to Seventh Avenue South.

However, it was not until 1926 that St. Petersburg's downtown beach on Tampa Bay was completed with a recreation pier and spa beach, called the Million Dollar Municipal Recreation Pier when it opened in 1926. While Brantley's Pier was the first recreation pier in Tampa Bay, it was nothing equal to the recreation pier and spa beach that was opened in 1926. The spa beach located on the waterfront on Tampa Bay became very popular with tourists during the boom era as they were often concerned over the "mosquito and palmetto infestations" on the Gulf beaches.

A picture showing the St. Petersburg beach is available on a 1940s postcard. On the back of that postcard was printed, "famed for its pure platinum sands, its balmy breezes throughout the winter and the placid waters of the bay, Spa beach in the heart of the city of St. Petersburg, Florida, is a popular recreation spot for all." The message was aimed toward the encouragement of tourism. The Million Dollar Pier was demolished in 1967 and rebuilt in 1973.

Another 1940s postcard shows the same downtown St. Petersburg beach from an opposite view facing the Vinoy Hotel. The hotel has a colorful history of its own and it was often used in city pictures to promote it as being first-class.

The Gulf island beaches were undeveloped before the 1930s. Yet there was an early Gulf beach community considered to be part of the St. Petersburg area called Pass-a-Grille. The 1908 city directory of St. Petersburg listed Pass-a-Grille as eleven miles southwest on the Gulf of Mexico with a four-mile boat trip from the Veteran City terminus of the trolley line. It afforded the finest in surf bathing, shelling, fishing, boating and all kinds of outdoor sports in the South. It had two hotels and a number of cottages.

Pass-a-Grille was a chain of islands and the two hotels at that time were the Bonhomie under the management of Mr. Geol H. Lizotte and the palatial LaPlaze Hotel. The rates for both hotels were between two dollars to ten dollars a day or starting at twelve dollars a week.

The John Klutts family lived on Pass-A-Grille in 1914 as he served as postmaster. By 1915, they lived on Tangerine Avenue and returned to the business community in St. Petersburg.

Several residents of St. Petersburg built homes in Pass-a-Grille and commuted to St. Petersburg. A ferry was the only access to the island until a toll bridge was built in 1919. After the toll bridge, it was possible to drive to the outskirts of St. Petersburg in fifteen minutes.

Yet the Don Ce Sar, as a hotel, stood all alone on the barrier island of Pass-a-Grille when it opened in 1928. The three hundred-room showplace hotel was originally conceived to be part of a Spanish-style subdivision but the Depression changed those plans. The Don Ce Sar survived by being a favorite luxurious seclusion for celebrated visitors and the hotel for the New York Yankees in their spring training during the early 1930s. Babe Ruth and Lou Gehrig were among the famous people who stayed there.

The history of Pass-a-Grille will reveal interesting stories by itself. One such story was the courtship of Pass-a-Grille's first bridegroom, T.A. Whitted, and his bride, Julia Jennette Phillips, in 1887. A romance bloomed between Whitted and Julia when she was thirteen years old and he worked in a mill near the island where her father had installed the machinery. To court Julia, Whitted sailed from Tampa Bay to Pass-a-Grille regularly for three years earning the title of "sailor in a sailboat." The wedding was the highlight of the Pinellas peninsula's social season. They settled in St. Petersburg in 1888 and their son became an aviation pioneer. The Albert Whitted Airport was later named for their son. There have been several other such stories.

Social attitudes about the Gulf beaches have changed in their one hundred-year history. Before the 1920s the beaches were viewed as mosquito-plagued, sand and salt land to be avoided. The place was useless and uncomfortable and residents often moved to or had other residences in St. Petersburg. By the post-World War II era, the same beaches were promoted as jewels among St. Petersburg's many assets. Metropolitan areas such as Tampa and Orlando competed for tourists, but they could not offer what St. Petersburg had as a subtropical paradise of sand and surf on the Gulf beaches. Pass-a-Grille became one of the most popular sunbathing and swimming sites along the state's west coast.

St. Petersburg citizens and tourists were granted easy access to the Gulf beaches when boom time prosperity brought enough money to replace the rickety old bridge with the Corey Avenue

Causeway and two smaller bridges linking the Gulf beaches of Treasure Island, Madeira Beach and John's Pass. John's Pass was another island seven miles north of Pass-a-Grille. It was another fishing ground, reached by pleasant rides among the Keys until bridges were built to connect all the islands.

A referendum was passed in 1957 to allow the neighborhood of Pass-a-Grille to have its own city hall, police and fire department. At that time, one thousand people lived on the island. A branch bank by First Security Savings and Loan became available as businesses developed on the island.

But major storms continued to send powerful waves across the Gulf islands and major beach repairs became necessary. As people built on the waterfront or close to the water, it became necessary for the state and local authorities to spend millions of dollars to keep the beaches. Such is the case today.

With easy access to both the Gulf and downtown beaches, a real opportunity for continued growth with the tourists trade came to St. Petersburg. However, were it not for the green benches, the Sunshine City would not have been so famous. It was the beaches that first aroused the interest of the winter visitors, but it was the green benches that kept them coming back. Home folks would take to the green benches as they lined the sidewalks along Central Avenue and the downtown streets. This gave an air of hospitality, cordiality and sometimes led to budding romances.

The green benches originated with Noel A. Mitchell, one of the first mayors, in front of his real estate office. He had fifty benches built and painted them to advertise himself as an honest real estate dealer. Scores of people came to Mitchell's corner at Fourth and Central, and the rest is history. It was Al Lang, another mayor, who made all the benches green and of a standard size in a city ordinance passed in 1916.

A writer for the *St. Petersburg Times* who called herself the Green Bench Lady wrote regular articles in the 1940s by "Broadcasting Some of the Things She Sees and Hears Up and Down Central Avenue During the Course of a Day." She obtained information while sitting on the green benches.

Another article in the November 12, 1951 *St. Petersburg Times* claimed that there were fourteen thousand sidewalk seats as the benches became a symbol of city hospitality. Each day of the year hundreds of people would gather downtown to greet and chat with friends. Their meeting places were on the green benches. Orderly rows of settees marched down the sidewalks of Central Avenue to the waters of Tampa Bay, as they appeared to grow out of the concrete; but that, of course, wasn't so.

The green benches were not only for resting and romance; there were times when business was conducted on the benches. Matthew Ryan, who had established a gift fruit-shipping business in downtown St. Petersburg in 1919, became fast friends with Mr. Al Lang when they met on the benches in the 1940s. As a result of the friendship, Ryan shipped fruit to the New York Yankees, which led to him shipping fruit to the New York Mets. By 1950, there were seven to eight thousand green benches throughout the city.

By the 1960s, the city council was concerned with the image of the city. It had become a haven for retirees. In 1950 there were 1 in 12 people in the area on Social Security.

By 1966, there were 1 in 3.4 people in the area on Social Security, showing a growing retirement population that the city council was beginning to be concerned about. The city council had all benches painted pastel colors to present a more youthful orientation. This proved to be unpopular and in 1967, an ordinance was passed to remove the benches from the city. In 1969, the last of five hundred benches were removed and the symbol of city hospitality was gone.

Unfortunately, removing the green benches changed the social perceptions from hospitality to one of senility and retirement; this was not what the city wanted. While the city council was blamed for removing the green benches, there was another developing factor that would have influenced the appraisal of the green benches: the advent of air conditioning. As air conditioning became more common, the green benches would have been abandoned when the hot summers forced individuals to choose air conditioning over the outdoors.

The social and historical significance of the green benches was later recognized when the week of November 10–17, 1991, was designated as Green Bench Week. Volunteers painted the benches green at bus stops and other locations in honor of the seventy-fifth anniversary of Al Lang's declaration. Since 1992, some of the benches have been returned as the city has made attempts to reestablish its reputation for hospitality.

While birds have always been a part of St. Petersburg, it has been the citizens who have historically provided for the birds. One such person and early citizen, Katherine Tippetts, founded the St. Petersburg Audubon Society in 1909 and served as president of that organization for thirty-three years. She fought for bird sanctuaries and animal protection legislation and was a major figure in the state bird movement. It was largely through her efforts that the mockingbird became Florida's state bird. She played an instrumental role in the establishment of the Florida Fish and Game Commission. She was symbolic of citizens' involvement in protecting the wildlife, but there were many others who protected the animals as well.

While feeding seabirds was a Florida tradition, St. Petersburg had more than one thousand pairs of breeding pelicans, one of the largest groups of pelicans in Florida. Later, nonprofit organizations started feeding the brown pelicans during the cool months when their food supply became scarce.

The Suncoast Seabird Sanctuary was founded in 1971 as human beings continued to infringe upon the wildlife and the birds needed to be rescued. Hundreds of pelicans, great blue herons, egrets, wood storks, seagulls and other injured species were healed and released back into the area by this organization.

One incident reported in the June 30, 1976 issue of the *St. Petersburg Times* revealed some bird lovers protesting dove research. Rexford Farewell, a retired attorney who watched and fed St. Petersburg's flock of ringed neck turtledoves for twenty years, was protesting a research group that put bands around the doves' necks. The bands were removed in response to Mr. Farewell and other citizens who complained to the governor, all showing how local citizens have continued to be involved in care for the wildlife.

However, by the 1990s, social attitudes toward supplying the seabirds with additional food were being questioned. An article in the March 12, 1995 issue of the *St. Petersburg Times* was

titled, "Good Deeds gone Bad." The director of the county Seabird Rehabilitation Center stated that "well intended treats to seabirds have caused a deadly dependency of the seabirds upon the handouts. When seabirds are fed, they start hanging out around places where they should not and end up being hurt." She observed a connection between well-meaning feeding and sick birds. She stated that "Often when looking for food, they get caught in fishing lines or they mistake bait for a free lunch and end up with a hook in their gut."

The *St. Petersburg Times* recorded other incidents with birds in 1993 and 1994. In January 1993, an article described the presence of toxins in the water and pelicans declining in the area. Fewer pelicans had been observed nesting and a comprehensive management plan was being developed to assess chemical contamination upon the pelicans. A March 2, 1994 article described cranes observed to be coming back but declared that they were still in danger. The article stated that as people move into the cranes' habitats, the cranes must be protected from being endangered in this area, and steps were described to protect them.

Then on August 12, 1994, following the second largest oil spill in Tampa Bay's history, volunteers from the Seabird Rehabilitation Center rescued the wildlife. County residents rushed to wash birds that were soaked from the oil spill. Because of local volunteer efforts, Public Service Commissions were presented to the volunteers by the commanding officer of the U.S. Coast Guard Marine Safety. Of the 317 birds rescued, 85 percent survived. The response program had seventy-five locally trained volunteers to help in any future oil spills.

A more recent *St. Petersburg Times* article dated October 10, 2005, discussed a current homeostasis between urbanization in St. Petersburg and the bird population. The current utility company has hired a biologist as their lead environmental specialist for the past two decades. His job is to protect the wildlife from wires and electricity and to protect their equipment from persistent wildlife. The article continued to talk about compromises that have been made as power employees leave active nests alone. Often, sensitive equipment must be moved out of the way of ospreys. If no young birds are about, workers relocate the nests to nearby platforms that look something like satellite dishes. About three hundred osprey couples have used the fiberglass nests to raise their young.

In the past, Pinellas County was a grand place for birds. Now seventeen million people have taken up space in the forests and swamps that used to be wildlife habitats and the local electric company must provide the power for those people. On paper, it should be bad news for ospreys. Instead, they are doing fine. They have adapted to the asphalt jungles and concrete as the citizens of St. Petersburg continue to protect their birds into the twenty-first century.

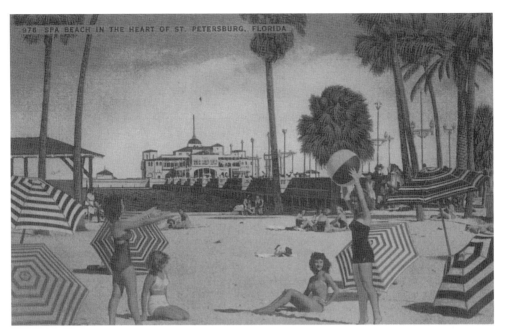

How the Million Dollar Recreation Municipal Pier looked in the 1940s.

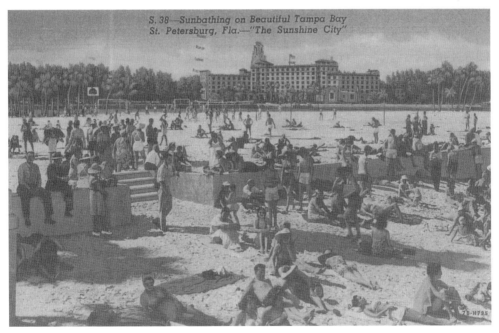

Another 1940s postcard shows the same downtown St. Petersburg beach from an opposite view facing the Vinoy Hotel. It is interesting to observe that some people were in swimsuits while others were in formal clothes. Others are playing games in the background. Notice the water between the beach and the Vinoy Hotel. The current boat docking facilities in front of the Vinoy were not developed at this time.

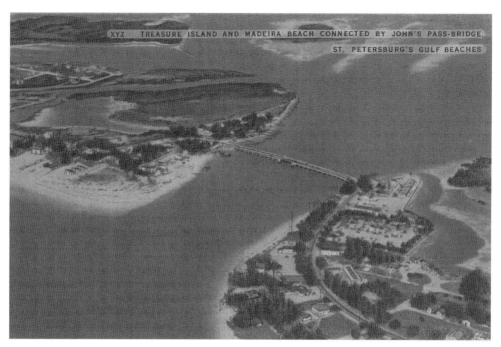

Another 1940s postcard shows the Gulf beaches of Treasure Island and Madeira Beach connected with John's Pass bridge.

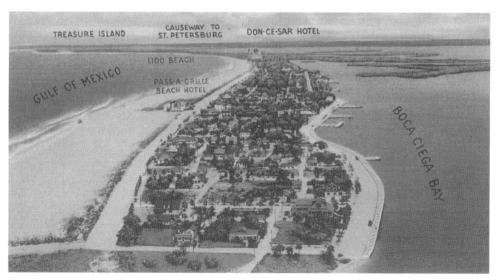

A 1930s postcard shows the Gulf beaches of Pass-a-Grille with two hotels, the Pass-a-Grille and the Don Ce Sar Hotels. The postcard was postmarked August 10, 1933, with the writer saying, "This is where we spent last night. My first experience on the beach will never be forgotten. I love it. My, how I've wished for you all! Everything is working out nicely and we are enjoying every minute. We are going to St. Pete this a.m. Love, M." Treasure Island, another one of the beaches, can be seen on the upper left side with a causeway to St. Petersburg.

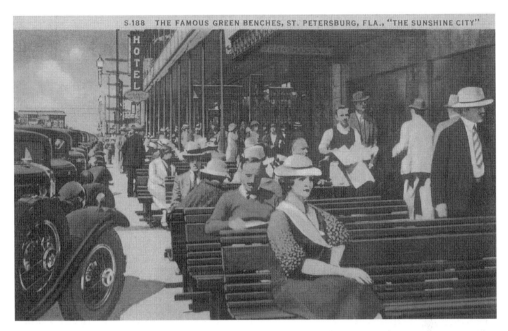

The green benches became a part of the city and its history. There are many postcards of the green benches but this one and the next two were chosen for their uniqueness of the people, cars and clothing styles.

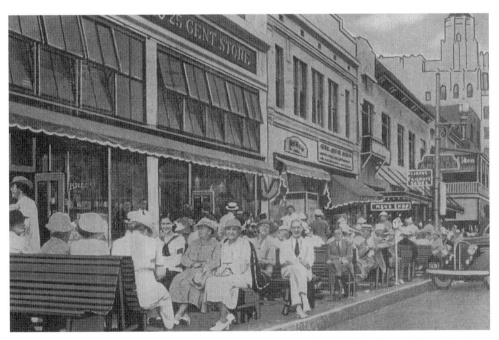

Another postcard of the green benches. The back of this postcard, labeled the Famous Green Benches, St. Petersburg, Fl, "The Sunshine City," states "that the famous Green Benches, which line the streets of the city, provide excellent resting places for shoppers and sightseers. From the acquaintances made while using the benches, St. Petersburg is known as the Friendly City."

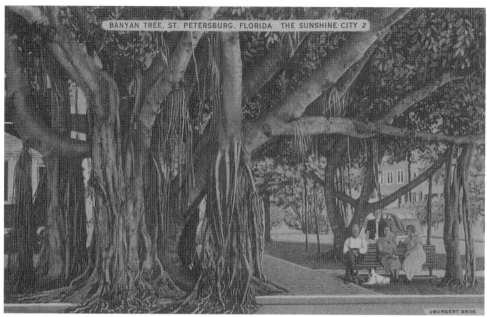

BANYAN TREE, ST. PETERSBURG, FLORIDA THE SUNSHINE CITY 2

A last postcard of green benches shows how they were scattered throughout many areas of the city, not just down Central Avenue. This postcard shows a green bench under a banyan tree, away from the crowd.

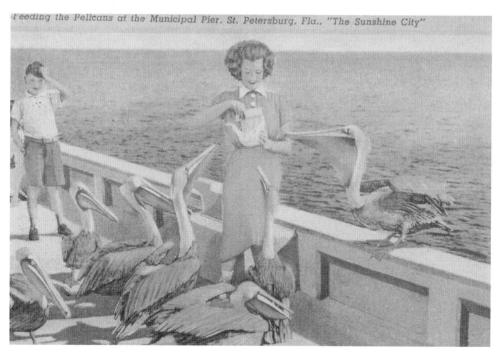

Feeding the Pelicans at the Municipal Pier, St. Petersburg, Fla., "The Sunshine City"

Feeding the seabirds became a common pastime at the Million Dollar Recreation Municipal Pier after it was completed in 1926. The following postcard shows how the pelicans were fed. This was a very common theme among postcards.

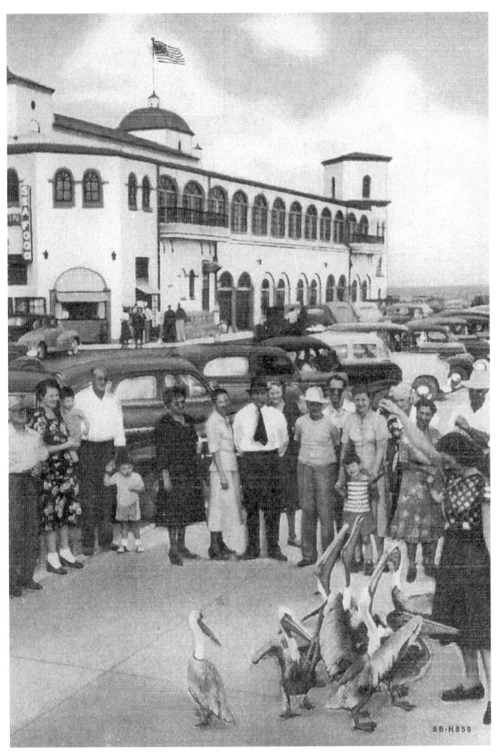

A 1950s postcard shows how interested tourists watched and observed the activity of feeding the pelicans at the Million Dollar Recreation Municipal Pier.

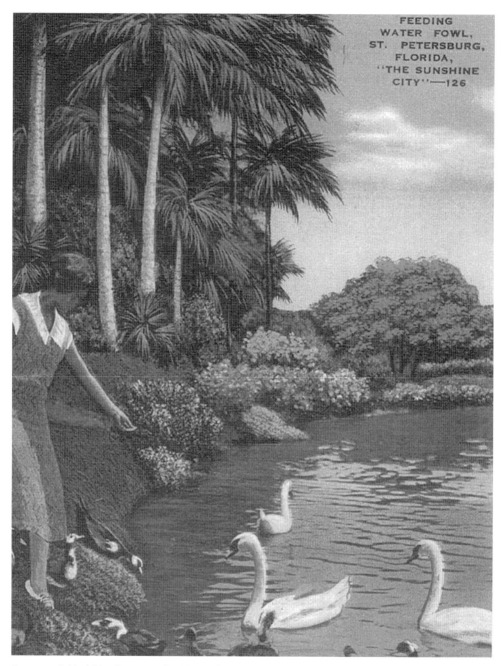

FEEDING WATER FOWL, ST. PETERSBURG, FLORIDA, "THE SUNSHINE CITY"—126

A postcard titled "Feeding water fowl in the Sunshine City" shows some of the birds of St. Petersburg while people feed them. The picture was taken at Mirror Lake, an early reservoir for the city and a refuge for the wildlife. As growing construction interfered with animal habitats, people developed more ways to protect the wildlife.

While the woman's leg might suggest something risqué in the postcard, it was probably a mistake in the printing process. However, it was preserved as a favorite postcard, either as symbolic for feeding the animals or for the risqué picture.

Bygone Hotels and Restaurants

B y 1905, the newly established city of St. Petersburg had a total of 675 hotel rooms. This was remarkable considering the fact that St. Petersburg officially became a city in 1903. The Chamber of Commerce was determined to fill the new city with tourists.

Those hotels included the Detroit with 100 rooms, the Manhattan with 100 rooms, the Colonial with 150 rooms, the Huntington with 100 rooms, the Wayne with 75, the Chautauqua with 50 rooms, the Paxton with 50 rooms and the Belmont with 50 rooms. Of those eight hotels, only one, the Colonial, survived as a hotel into the twentieth century. However, that is even questionable because the original Colonial Hotel burned to the ground in 1907. A second Colonial Hotel was built in 1921 and continued into the year 2000. During this time, many restaurants have also come and gone.

The first hotel, the Detroit, was built in 1888 and is pictured in a postcard before additions were made in 1914. The rates in 1916 were listed as three dollars and up.

A restaurant was added to the Detroit Hotel later and it was advertised in the December 5, 1926 *Daily News*. Two sons of Mr. M.J. Doran, who had gained fame during the 1900 Buffalo Pan-American Exposition with a restaurant, were to operate the Detroit restaurant in St. Petersburg. They came to St. Petersburg after an extended study of the tourist trade of Florida and selected St. Petersburg as the logical point from which to start their statewide enterprises. They were expecting to expand into Tampa, Fort Myers, and other cities in Florida.

The restaurant provided à la carte service with every "conceivable restaurant delicacy." Room service to the Detroit Hotel was to be available at all times and the entrance to the shop was through the hotel lobby.

By 1980, the Detroit Hotel was facing threats of closing and the whole Detroit block needed to be renovated. The existing buildings around it from Central Avenue to First Avenue North and extending to Second and Third Streets were all renovated. In 1982, there was a grand opening of the area behind the Detroit Hotel, called Jannus Landing. It was turned into a

French quarter-style blend of shops and office court. By 1993, the hotel was closed. Jannus Landing continued with shops.

Since the old Detroit Hotel was important to the history of St. Petersburg, it was not torn down but it was badly outdated. It sat empty until the year 2002, when the old Detroit Hotel was renovated into twenty-four modern condominiums. The area now includes a hotel, lobby bar, a garden restaurant, Ticketmaster, Detroit Liquors, Bertoni's Restaurant, Jannus Landing Concert area, a Tamiami Bar and Benson's Restaurant. The old hotel did survive into the twentieth century, but not as a hotel.

The Manhattan Hotel started as a hotel in 1905, but it had already existed as a home for St. Petersburg's founder, John C. Williams. John C. Williams first brought his wife and children to the area in 1879 and bought 1,700 acres, much of which is now downtown St. Petersburg. He bought the James S. Hackney home, a four-room shanty, and made plans to build a grand house on the land at Fifth Avenue South and Fourth Street. The home was finished around 1891-2. The house was a Queen Anne-style mansion with a beautifully carved staircase, ornate doorways and fifteen rooms. The house had striking features of a steepled roof and a widow's walk. While the house was similar to other fine houses during that period of St. Petersburg, few now remain. John C. Williams died in 1892 and the home was sold off in the next few years.

Seventy- five rooms were added to the Williams house and it became part of the Manhattan Hotel as early as 1905. In 1928, the whole structure was moved two hundred feet west to make room for St. Mary's Catholic Church. This achievement was attributed to the sturdiness of both the Williams house and the added rooms.

The Manhattan Hotel was later expanded to eighty-seven rooms. The rooms claimed to have steam heat, extensive verandas and tropical grounds. It was a five-minute walk to the parks, waterfront and all activities.

The attached rooms were demolished in 1994 to make a way for a children's hospital. The Williams home was moved to the University of South Florida and restored back to its original condition. It is now used for administrative offices at the University of South Florida.

More hotels were added to the early city. The Poinsettia Hotel was opened in 1911 as the city was experiencing a small growth boom. Mr. C.M. Roser built the Poinsettia as he was buying and selling other downtown property. He developed Roser Park.

Mr. Roser promoted the hotel as a modern hostelry, on the south side of Central Avenue between Fourth and Fifth Streets. By 1915, traffic jams were often observed in front of the Poinsettia Hotel with nearly every type of conveyance in use: early cars, horses and carriages and tandem streetcars with large groups of people. In 1916, the Poinsettia rates were $1.50 and up. The hotel was being frequented by salesmen. There are three interesting pictures of the Poinsettia Hotel, the last showing the coffee shop.

Information from the Historical Society shows that this coffee shop was opened in 1921 to provide for some three hundred guests. At that time, a great brick fireplace formerly of the old lounging room was part of the coffee shop. An orchestra provided special programs during the lunch and dinner hours.

In 1942, all 108 rooms at the Poinsettia Hotel were opened up for the military solders. As the city grew into the 1950s and '60s, parts of the downtown were torn down for newer buildings. Somewhere in that time, the Poinsettia Hotel was replaced with newer buildings.

Another hotel worthy of consideration was called the West Coast Inn, built around 1916. It was considered a "health spa" on First Street and Third Avenue South. In 1916 the room rates were four dollars and up. Free concerts twice a day by fine and professional bands were advertised. The hotel claimed to have seventy-eight rooms and a view of Al Lang Field.

During World War II, the West Coast Inn was used for military soldiers. In 1957, the West Coast Inn was renovated and it was demolished in 1967. It was replaced with a new St. Petersburg Hilton.

Beginning in 1921, St. Petersburg still had fewer than five hundred hotel rooms and there were over thirty thousand tourists looking for rooms. Local businessmen were borrowing money as quickly as possible to build more hotels. A dozen new big hotels were built, one of which was the Soreno, opened in 1924. It was the city's first "million dollar hotel." It was designed in Mediterranean revival style.

The Soreno Hotel housed servicemen in its three hundred rooms during World War II. The hotel was closed in 1985 and imploded in 1992. It became the site for condominiums built on the same location, called Florencia, by the end of the century.

Most of the St. Petersburg hotels were built in the boom era of hotels. One, the Ponce de Leon, was built in 1922 with 85 rooms and still continues as a hotel following some renovations. Another, the Vinoy, was built in 1926 with 367 rooms and still continues as a hotel following renovations. The Pennsylvania Hotel was opened in 1926 and continued for years until more recent changes have put its status into limbo. The Dennis Hotel, opened in 1926, has gone through several name changes and renovations but still remains as a hotel. The Don Ce Sar located on Pass-A-Grille became a hospital during World War II but now continues as a hotel following some renovations.

Other boom era hotels did not survive as hotels. The Alexander, built in 1919 with 74 rooms, later became an office building. The Royal Palm is gone. The Cordova, built in 1921, is torn down; the Suwannee, built in 1923 with 205 rooms, is a county office building; the Pheil, opened in 1924, became part of the First National Bank building; the Mason, opened in 1924, became the Princess Martha Hotel and later the Princess Martha Retirement Facility.

The restaurants have met similar fates. A well-known restaurant called Aunt Hattie's was opened in 1939. Aunt Hattie's was known as a family restaurant with chicken and dumplings, cinnamon rolls and chocolate pie, located at 625 First Street South across from Albert Whitted Airfield and the West Coast Inn. Patrons could expect to be handed a number at the door, with seating sometimes taking an hour. The delay never deterred customers, for the restaurant was a museum full of antique treasures.

Harriet and Frank Boore had owned and operated the restaurant since 1939 and their son continued it in 1962. While Mr. and Mrs. Boore owned the restaurant during World War II, their son related how servicemen would buy their five-ounce hamburgers for fifteen cents. They would take the burgers to the nearby marine base at Bayboro Harbor and resell the burgers to people in

quarantine for twenty-five cents. The son of the original owners took over the restaurant in 1962 and sold it in 1979.

The last restaurant to be discussed in this chapter was a more exotic one called the Wedgwood Inn, across from Bartlett Park. Located at Fourth Street and Eighteenth Avenue South, it opened in 1946. The restaurant was canopied by huge trees and built alongside a creek and its dining room was shrouded with exotic flowering plants and trees. One of the shady glassed dining rooms featured an aviary of colorful birds. Tourists were enchanted by the lush greenery surrounding the tables and the music, provided not by an orchestra but by the melodious songs emanating from a giant aviary of exotic birds that shared the dining room with patrons. The restaurant claimed to have the world's best apple pie with lunch prices from $0.85 to $2.50 and dinner from $1.10 to $3.00. While the restaurant food was recommended by Duncan Hines, the garden room was known for being "a must" to see.

This restaurant had another claim to fame: it had one of the world's largest private collections of old Wedgwood on display for free. Other postcards that were published about this Wedgwood Inn usually included parts of their Wedgwood collection. One showed the Wedgwood chandelier in the foyer, circa 1780, while another postcard gave a history of Josiah Wedgwood as master potter from 1730 to 1795, while advertising the Wedgwood Inn in St. Petersburg and later, two other restaurants in Daytona Beach and Atlanta. The St. Petersburg restaurant changed ownership fifteen times and was closed in 1982.

These two restaurants have gone as their owners aged or left. There have been many new restaurants to develop but those recorded in old postcards reflect a different era and time.

There are still many more old postcards of hotels and restaurants that people have preserved. While many are so common that they would not create any general interest, most of those postcards had special meaning to those who preserved them. Recognizing how people used postcards of their favorite hotel or restaurant as a memory of those events is a social history of that time.

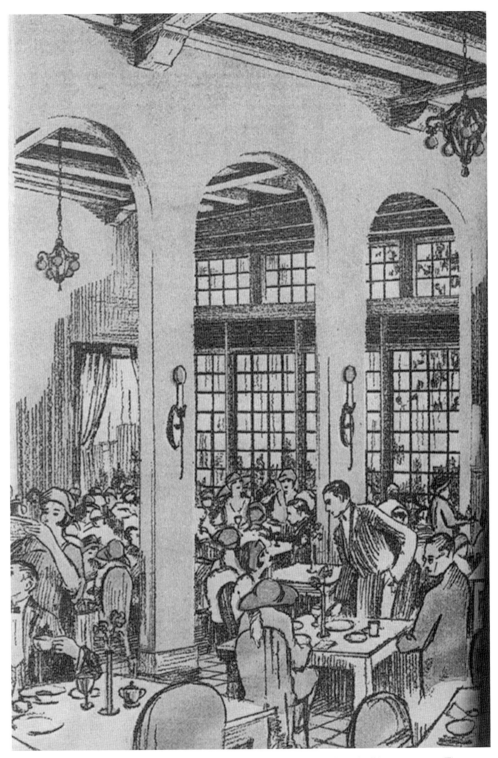

A copy of a picture of the Detroit Restaurant published in a local black and white newspaper. The article was published in beautiful color.

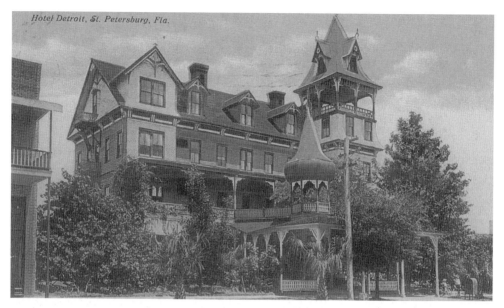

A less common postcard of the Detroit Hotel even though there were many pictures made of this hotel.

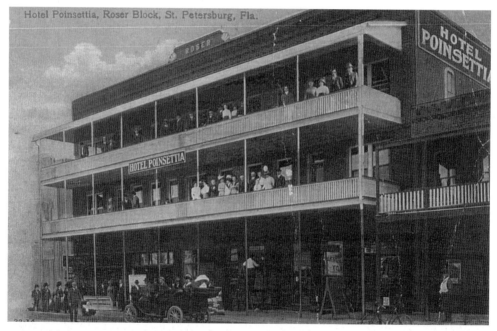

A postcard of the Poinsettia Hotel with many people present. Both this postcard and the next postcard of the Poinsettia were published by A.B. Archibald of St. Petersburg, who operated Archibald's Quality Shop at 442 Central Avenue. Mr. Archibald and his wife, Katie were listed in the city directory as owners of an ice cream parlor at 434 Central Avenue in 1908, at 439-440 Central Avenue in 1915 and located later in another hotel, the St. George, at 439 Central Avenue. Mr. Archibald has been identified as being in the real estate business in the 1920s with his office at 341 Central Avenue.

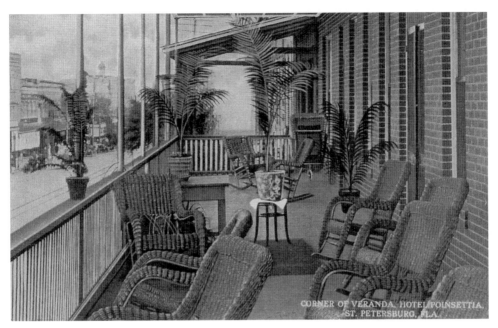

A unique view from the veranda of the Poinsettia Hotel. Notice the foliage and wicker furniture.

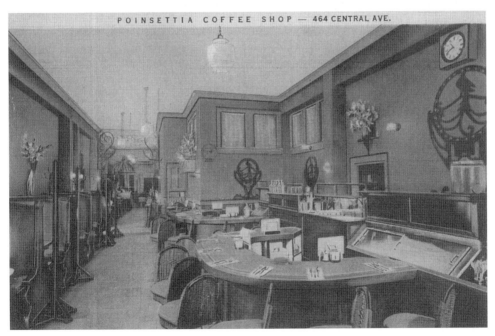

The coffee shop in the Poinsettia Hotel. This 1940s card advertised the coffee shop as a "distinctive place to eat in pleasant surroundings and atmosphere. It was famous for steak and seafood dinners with delicious coffee and pastries. Located in the heart of St. Petersburg." This postcard was published by a Chicago publisher, Curt Teich Co., a prolific producer of American postcards but not a local company.

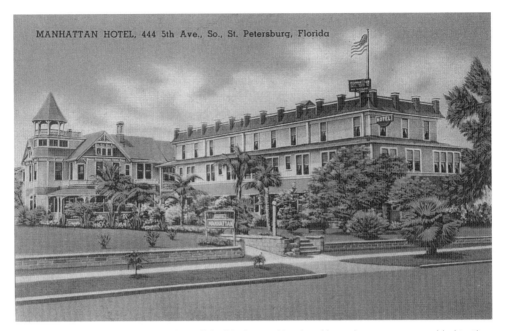

A 1950s postcard shows a wider view of the Manhattan Hotel and how the rooms were added to the Williams home.

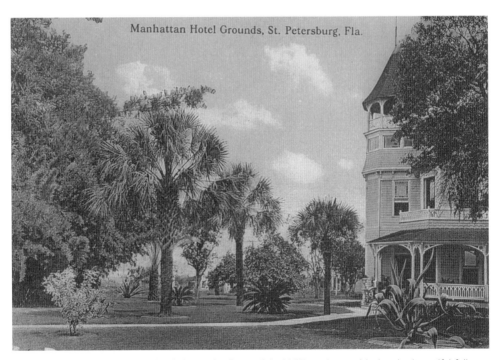

A postcard of the Manhattan Hotel shows the front of the Williams house. Notice the beautiful foliage around the front of the house, typical of the time.

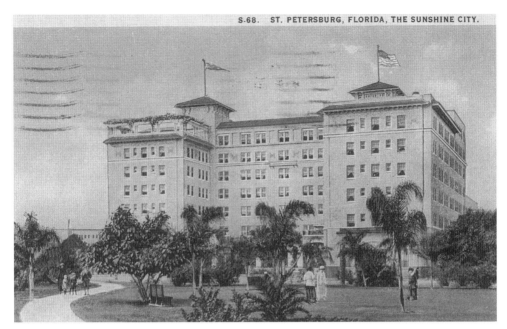

S.68. ST. PETERSBURG, FLORIDA, THE SUNSHINE CITY.

This postcard shows the Soreno Hotel as it looked in 1926. A message written on the back of this postcard states, "We took in the sights at this place. It is a very beautiful place. St. Petersburg has sunshine every day."

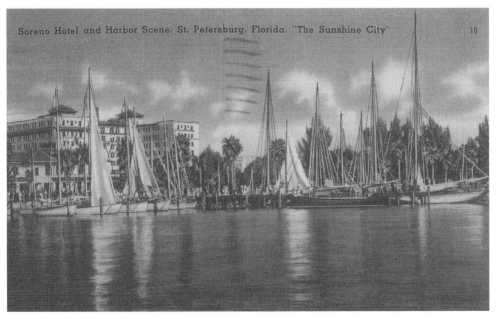

Soreno Hotel and Harbor Scene, St. Petersburg, Florida. "The Sunshine City" 10

Another postcard of the Soreno Hotel in 1944 shows it surrounded by waterfront. Writing on the back of the postcard reveals another interesting fact. "A Final Florida Greeting. Announcing another Firemen's Meeting. Monday March 13, 1944. Signed, F.P. Volikmann." The postcard was sent to a Mr. Peck in Prattsville, Greene County, New York.

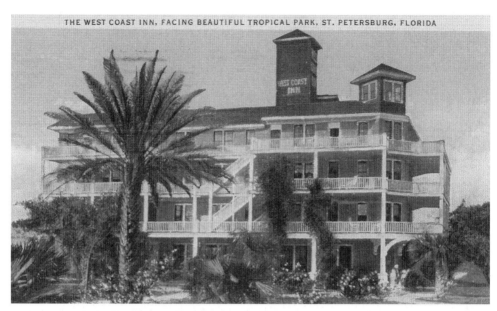

THE WEST COAST INN, FACING BEAUTIFUL TROPICAL PARK, ST. PETERSBURG, FLORIDA

A 1945 postmarked picture of the West Coast Inn. Listed on this postcard is Charles A. Weir as president and manager of the hotel. He gave a second address during the summer at the Ontwood Hotel, Mt. Pocono, Pennsylvania. All this supported the known fact that all St. Petersburg hotels closed during the hot summer. Since air conditioning was still undeveloped, the hotels at this time were expected to be closed during the summer months.

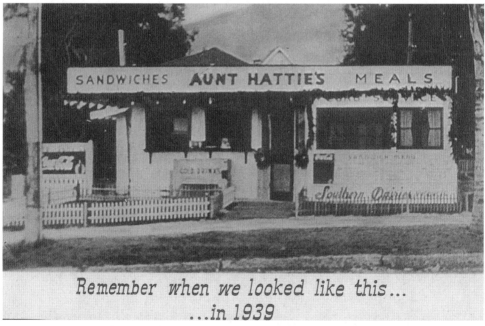

SANDWICHES AUNT HATTIE'S MEALS

Remember when we looked like this...
...in 1939

A postcard shows how Aunt Hattie's looked when it opened and seated only sixteen people. The postcard was published by R.E. "Bob" Schatzman, 1126 Seventy-seventh Street North, St. Petersburg.

A 1960s postcard of Aunt Hattie's states that the "famous St. Petersburg Restaurant was air conditioned and had a seating capacity of 175. The new all electric kitchen and selected dining room personnel was to assure each diner of prompt, efficient service." This postcard was published by a New York publisher, different from the previous local ones.

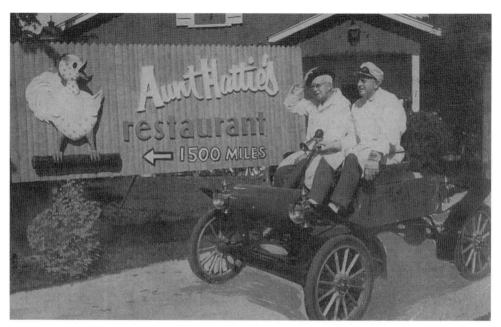

Another postcard of Aunt Hattie's was published by Cotton & Schatzman of St. Petersburg, advertising the famous family restaurant, "Where Home Cooked Food is Not Just an Expression" and "under original management since 1939." This postcard reflected the owners' interest in antiques. It detailed information about the pictured automobile on the postcard front. It was a replica of a popular 1903 model, weighing seven hundred pounds with an eight horsepower one cylinder motor. It had two speeds forward and one in reverse. It had a top speed of thirty-five miles per hour and fuel consumption was approximately sixty-five miles per gallon. The tires were pneumatic.

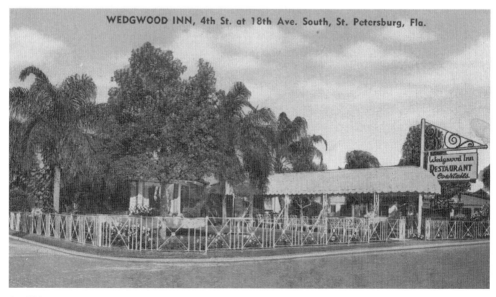

A 1950s postcard shows the front of the Wedgwood Inn Restaurant.

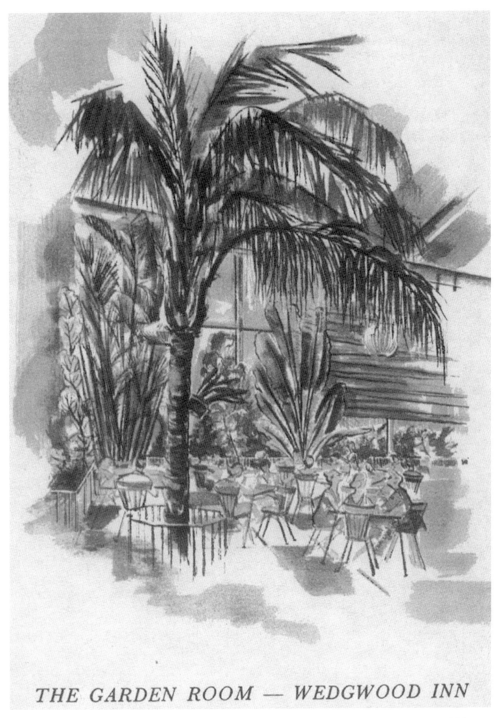

THE GARDEN ROOM — WEDGWOOD INN

A last postcard of the Wedgwood Inn Restaurant in 1959 shows a picture of the garden room, which was "a must to see," stated in the advertising on the postcard's back. It claimed to have a large variety of foods with "lunch from 85 cents to $2.50. Dinner was from $1.10 to $3.00 and recommended by Duncan Hines. One of the largest private collections of old Wedgwood was always on display and free to see."

Fishing, Foliage and Fruit

All three interests (fishing, foliage and fruit) have helped to draw settlers, residents and tourists into St. Petersburg in the past and present. While fishing and fruit became major sources of income, the beautiful foliage added beauty to the lives of visitors and locals. People were attracted to the city for at least one of these attractions.

Fishing was the first major industry of St. Petersburg before 1890. With the introduction of the Orange Belt Railroad the previous year, the pace and scale of that early industry escalated. Although the lifeblood of the economy had been commercial fishing, making a living in the St. Petersburg area had never been easy because getting the fish to a warehouse in Tampa was difficult. With the introduction of the Orange Belt Railroad and the creation of a local market, commercial fishing became much easier and much more lucrative. The Orange Belt Railroad built a pier three thousand feet long into the water from First Avenue South and added a bathing pavilion in 1890.

The railroad pier was the pride of the local business community and the hub of the downtown waterfront. It had an artesian well for freshwater showers and a toboggan slide. It was lined with loading docks, warehouses and facilities for everything from small freighters to vacationing bathers.

By the late 1890s more than two hundred fishermen were involved in a trade that produced as much as three million pounds of fish a year. As the fish industry grew, so did other related industries. Ice plants for packing the fish were opened. Fish houses in St. Petersburg were soon shipping huge quantities of mackerel and snapper to cities along the eastern seaboard.

Henry Hibbs opened his fish house and continued to encourage more commercial fishermen in St. Petersburg. He was shipping more than one thousand pounds of fish a day. Soon other local fish houses along the wharf were shipping more than three million pounds of fish a year to ports all over the country.

Henry Hibbs invented a sail car to bring ice from the icehouse to the end of the pier. It became an oddity and an attraction that has often been pictured in history books. It continued

to be used until it ran down and fatally injured a winter visitor who was fishing on the pier. It was never used again.

People boarded steamships from the railroad pier, as shown in a postcard. There had been two steamers of the Independent Line, operating since 1899 to provide transportation to and from Tampa. It was far easier to cross the bay between St. Petersburg and Tampa by steamer than by the long arduous trip on land at that time.

By 1906, a second pier for a different steamer, called the *Favorite*, was extended three thousand feet into the bay to load and unload passengers. Electric trolley tracks were extended to the pier's terminus where a five hundred-passenger steamer could board them. It was called the Electric Pier. The Electric Pier was replaced with a wood Municipal Pier in 1913 that included a bathhouse, solarium and beach.

While many local individuals participated in the activity of fishing, fishing without any swimming facilities did not attract tourists, so the wood Municipal Pier served that purpose until it was severely damaged during the 1921 hurricane. A replacement was needed. A bond issue was approved to build a modern state-of-the-art recreation pier that would rival all others.

Lew Brown as editor of the *Evening Independent*, a local newspaper, had mounted a drive to raise money for the pier. Another local newspaper, the *St. Petersburg Daily News*, did an illustration of Santa Claus bringing the Municipal Pier to Miss St. Petersburg on December 19, 1926. All of these images show how important a pier was to the local citizens. The Million Dollar Municipal Recreation Pier was completed in 1926 and both fishermen and tourists enjoyed it for many years.

Fishing was also popular along the west side of the county peninsular, called the Gulf beaches. I discovered a 1919 St. Petersburg beach brochure and Florida road map showing a catch of tarpon at Pass-a-Grille. It stated that the finest fishing found anywhere in America was at Pass-a-Grille during a twelve-month season. Pass-a-Grille, as reported in the brochure, "is one and one half miles from the wonderful city of St. Petersburg connected by brick roads and a good free bridge." The beaches with their own towns of Pass-a-Grille, John's Pass, Madeira Beach and Treasure Island were flocked by the tourists.

Other fishing maps as early as 1946 were found at the St. Petersburg Museum. Locations of fishing havens were available throughout the county as advertisements to tourists. While the municipal piers, past and present, have been viewed as major sources for fish, surrounding areas have increased in fishing activity.

Some fishing havens were created through disasters, as in the recent case of the Sunshine Skyway collision and collapse in 1980. As a new Skyway Bridge was built following the collapse, the old bridge was left for fishing. By 1990, there had been a steady stream of anglers who found certain species of fish around the collapsed bridge. Fishing has always been important for both the economy and the tourist trade.

The beautiful foliage was always a part of early St. Petersburg. The foliage was often photographed as tropical foliage seen on the Braaf Residence. The Braaf property was located on Fifth and Sixth Avenues on the south side of Beach Drive, now part of the Vinoy Hotel.

A postcard was sent in 1923 with a return address of 1660 Central Avenue, St. Petersburg, Florida. The writer who identified herself as Grandma stated, "I have seen a number of trees like this one on this card and I can't still recall all the beautiful things we have seen. We were taken as far as the Gulf of Mexico one day which I never expected to see." Postcards were often sent home telling of the beautiful foliage.

Early residents of St. Petersburg took care of the foliage that they found in the area. In 1949, the local Horticulture Committee made a list of vegetation in and around St. Petersburg. They listed the bougainvillea vine as being very common to St. Petersburg.

The Horticulture Committee identified 37 different kinds of palms and palmettos. The 1949 horticulture list identified 74 different ornamental vines, 127 ornamental trees and 103 ornamental shrubs and small trees, all around streets and houses. Two of the listed ornamental trees are shown on postcards. There were 17 other miscellaneous types of foliage, all showing the variety that was part of early foliage in the city.

As the city continued to grow with more buildings and homes, the foliage suffered. There were many times when the city tried to preserve the foliage, often resulting in failure. In 1960, a city nursery was created where seventeen thousand types of plants were maintained and replanted after construction was finished.

Some foliage could not be replaced, such as the banyan trees. Many beautiful banyan trees were uprooted from construction and lost forever. A more recent example occurred in the late 1970s when a beautiful banyan tree was uprooted at the foot of Central Avenue and Beach Drive, the planned site of Bayfront Tower and the first downtown condominium. It was labeled as one of the city's first environmental battles over an art deco-styled Chatterbox restaurant with an adjacent giant banyan tree. The Chatterbox was moved to another location but the banyan tree was lost forever.

Yet many individuals preserved the foliage by developing their own gardens. As early as 1949, the city had fourteen gardens of "interest." One of those gardens, established by the Turner family, became known as the Sunken Gardens. George Turner, a plumber, arrived in St. Petersburg in 1902 and acquired property on Fourth Street soon after arriving. The property had a sinkhole and pond where he drained the water off the pond. He used the soil to grow flowers, vegetables, bananas and papayas and planted citrus trees in the surrounding soil. He sold vegetables and fruit to supplement his plumbing income. Soon he had more visitors than customers and he started charging admission.

By 1940, the Sunken Gardens was not just a tourist attraction but a social center as well. There were weddings and receptions taking place on the green lawns by the old pond while school and civic groups held teas and fashion shows there. A son, Ralph, and other family members continued to operate the facility.

Foliage in St. Petersburg was highly prized, as evidenced by the large number of postcards that showed it. Foliage was often used to boast about the early city and the beauty that surrounded it. All that was caught on old postcards survived longer than much of the foliage.

The fruit industry did not develop as well as the other interests. Even after the railroad arrived in St. Petersburg, commercial farming, including fruit, remained difficult, as items

were perishable. Freight rates were often exorbitant and the St. Petersburg farmers could not compete with more centrally located Florida farmers.

William L. Straub, as editor and part owner of the *St. Petersburg Times* in May of 1902, boasted of a surrounding county dotted with the finest orange, grape, tangerine and other citrons, fruit groves, pineapple plantations, truck farms and gardens in Florida.

A 1902 prospectus on St. Petersburg gave glowing examples of ample fruit growing in Pinellas County around St. Petersburg. Large watermelons, ten-pound pineapples, a forty-one pound melon, fine peaches, and even large cabbages, fine potatoes and immense squash were all reported as examples of fruits and vegetables growing in the area. It was all part of a local effort to praise the agricultural potential and encourage more settlers into the area.

W.L. Straub also described St. Petersburg in 1902 as having two thousand inhabitants, eighty-four businesses, eight churches, schools, a volunteer fire department and opera house with many fruit trees and citrus bushes. Fruit was often displayed in postcards.

As early as 1900 there were 1,200 acres of Pinellas County in citrus with the orange and grapefruit crops valued over $250,000. One of the largest growers was John S. Taylor. There were also other families such as William and Mary Eaton who had their groves located west of Ninth Street near Twenty-first Avenue North. Crates of oranges and grapefruits from the Eaton Groves were transported to packinghouses after the pickers had done their jobs. It was after 1922 when W.T. Eaton started subdividing his groves into homesites, reducing the groves that had produced fruit for years. The practice of dividing of groves into homesites became a common practice.

As early as 1907, there were three large citrus packinghouses in St. Petersburg. Oranges sold for $2.50 a box. One of these packinghouses, the Golden Sunset, was opened in 1919. It was known for "giving tourists a taste of sunshine."

By 1929, Pinellas County was the second largest grower of grapefruit in the state. By 1956, the number of acres had dropped and by 1986, fruit groves covered only 394 acres. As homes, schools and people multiplied, the citrus industry was pushed out of the county.

As the fruit industry decreased, the owners combined two sources of income, as in the case of the Wever Groves Hotel and their citrus groves. The hotel was opened in 1921 by Milledge Davant Wever. Earlier in 1899, he had brought his family to St. Petersburg and specialized in growing citrus. He continued with his groves but later opened his hotel. He catered to the middle class since the Wever Groves Hotel was not considered one of St. Petersburg's grand hotels. The Wever Groves Hotel was located at First Avenue South and Sixth Street with a Wever's Citrus Groves salesroom in the hotel building. The owner died in 1956 at the age of ninety and his hotel was closed in 1977. There was no mention about his groves later in his life, so a safe assumption would be that he had already disposed of them as the city encroached upon his land.

In another example of the changing citrus industry, John Thornton, after finishing St. Petersburg High School, established the Hitching Post in 1931 at 1622 Central Avenue in St. Petersburg. He traveled to the next rural town, Largo, to fill his truck with oranges,

grapefruits and all the citrus he could sell since local fruit was becoming scarce. The Hitching Post became an important citrus business for St. Petersburg by the late 1930s. During World War II, the Hitching Post was the city's source of bananas and fruit. By 1945, Thornton moved the Hitching Post to 1644 Central Avenue and sold the business several years later. John Thornton spent his next seventeen years working for Doc Webb as division manager of the food department, as he found local citrus had became too difficult to find. He changed professions as the local citrus industry decreased.

The citrus industry started with the early settlers such as W.L. Straub, who told of his ten-pound pineapples, creating a sensation in the 1901 *St. Petersburg Times*. There were 1,200 acres growing citrus in Pinellas County, which included St. Petersburg, and the citrus industry was expected to only increase since the climate was favorable. However, unforeseen by the early settlers, the St. Petersburg real estate industry developed a much greater demand for homes and buildings than for fruit groves. As St. Petersburg grew into a larger city, the land became more valuable as homes than as crops. At a time when the citrus industry had been the second largest industry in Florida, St. Petersburg's land was used for housing rather than crops and individuals who depended upon the citrus industry had to change with it.

There was a more recent citrus business started in 1946 called the Orange Blossom Groves. At that time, Al Repetto expanded his father's land into thirty-eight acres of groves and hired as many as three hundred workers during the winters. He developed a retail store and mail order service that developed into a $12 million business until 2005. He closed his business after some of his groves were destroyed from citrus canker and his land was more valuable as home developments than fruit groves. He viewed Mother Nature as too difficult to fight. His fruit groves were being sold as many home developers competed for his land.

The *St. Petersburg Times* described the closing of the Orange Blossom Groves as the last citrus grove to fade into the Pinellas County history. A victim of economics and Mother Nature, it was the only commercial grove left in the state's most densely populated county. Just a few decades ago, much of Pinellas County was covered in orange groves and now it has lost its last citrus grove. The end of that industry has come.

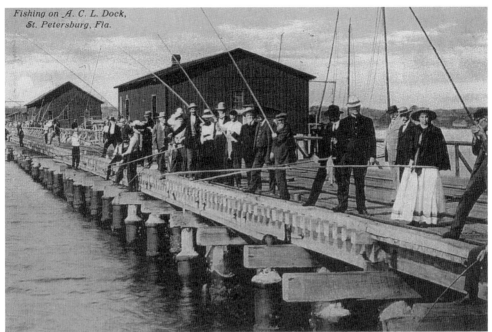

Fishing on A. C. L. Dock, St. Petersburg, Fla.

This postcard shows people fishing off the railroad pier without any indication if the people were tourists, locals or commercial fisherman. Since this was the only pier at the time, the people may have been a combination of all.

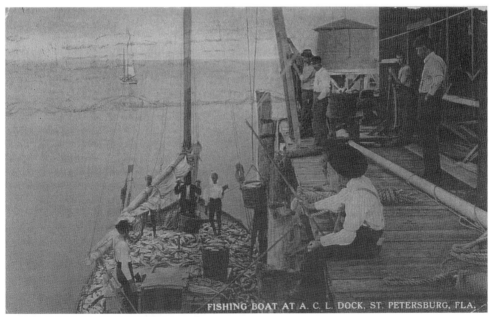

FISHING BOAT AT A. C. L. DOCK, ST. PETERSBURG, FLA.

A postcard shows the Atlantic Coast Line railroad pier as a boat is loaded with fish. The ACL railroad pier was the pride of the local business community.

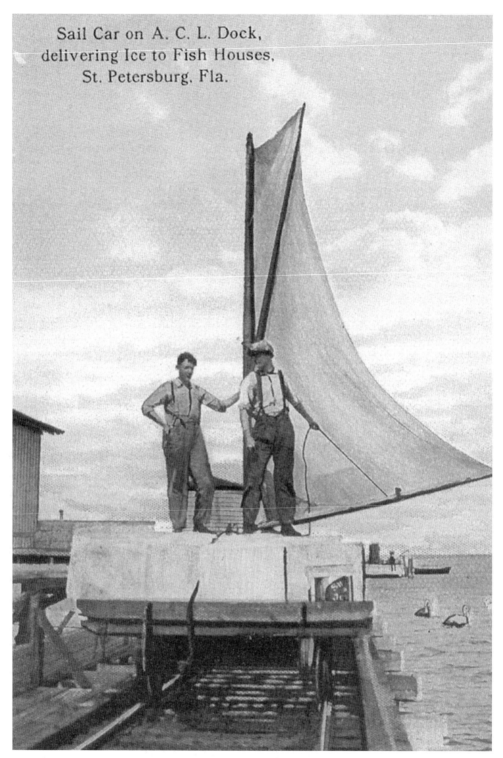

Sail Car on A. C. L. Dock, delivering Ice to Fish Houses, St. Petersburg. Fla.

This postcard shows the sail car. While the sail car was not used long, it gained such interest that it was pictured on many early postcards.

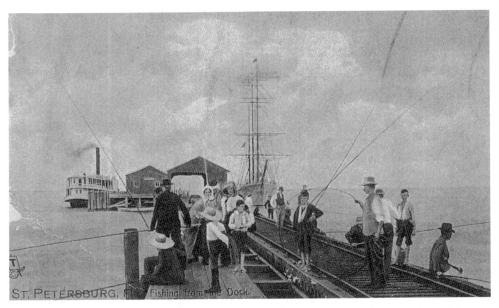

ST. PETERSBURG, Fla. Fishing from the Dock.

This postcard shows a steamship docked up to the pier with people fishing. Since there is no visible name for the steamboat it was likely that this is one of many boats that docked at that pier as others fished. Another pier, Brantley, was built to board passengers onto steamers and that pier became the Electric Pier as it was extended three thousand feet into the bay. The Electric Pier was replaced with a Municipal Pier that was destroyed by a storm. Then the Million Dollar Recreation Municipal Pier was built and remained in use for many years.

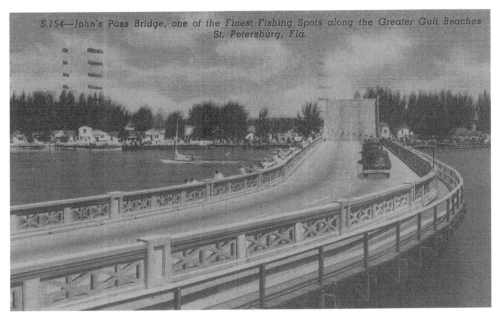

S.154—John's Pass Bridge, one of the Finest Fishing Spots along the Greater Gulf Beaches
St. Petersburg, Fla.

Fishing was an important part of the Gulf beaches and a postcard shows John's Pass Bridge in the 1950s as "one of the Finest Fishing Spots."

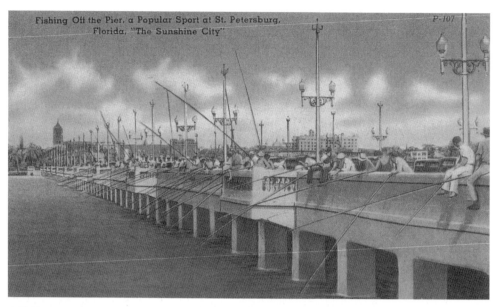

A 1940s postcard shows the Million Dollar Pier with many fishing poles hanging off the sides stating, "providing a pleasant promenade, half a mile out into Tampa Bay, as fishing was always a part of the activities." The postcard stated that there was "no better fishing anywhere than in the waters of the Bay of St. Petersburg. Fishing from the Municipal Pier is the mildest and least strenuous form of this popular sport."

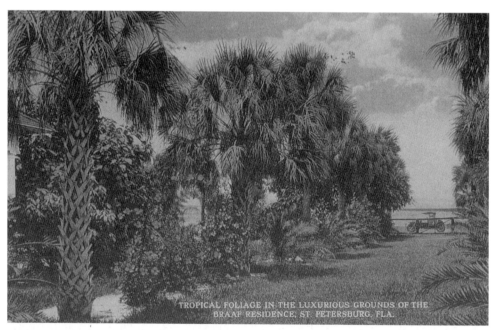

A postcard showing the Braaf residence grounds shows some of that foliage. Notice the old car parked next to the water. The Braaf residence was located at 609 Beach Drive through 1915 as the Vinoy Hotel was built at that location in 1925. The location was considered a showplace because of the beautiful foliage.

The bougainvillea vine. This postcard explained on the back that "the bougainvillea is especially adapted to growth on pergolas and trellis work, and is considered by many to have the finest coloring of all of the brilliant plants that grow in this subtropical state."

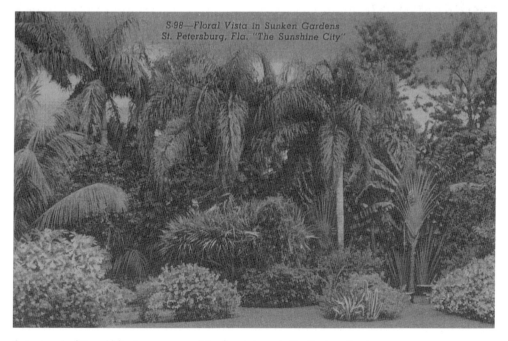

A postcard of the 1950s shows some of the floral views in the Sunken Gardens.

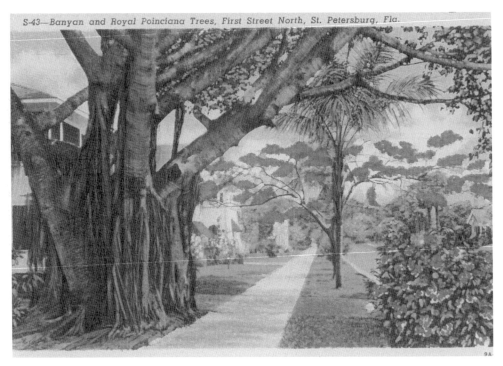

S-43—Banyan and Royal Poinciana Trees, First Street North, St. Petersburg, Fla.

Two of the listed ornamental trees, the banyan and poinciana trees, are shown. They were prominent throughout the city.

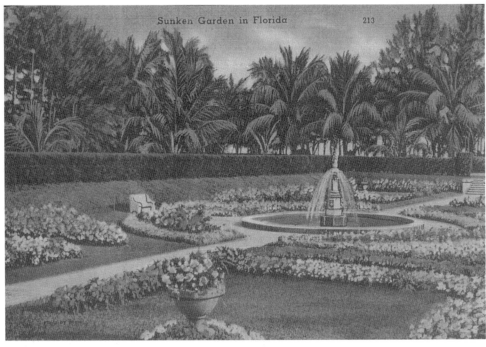

Sunken Garden in Florida 213

Another postcard shows the flowers and waterfall of the beautiful Sunken Gardens.

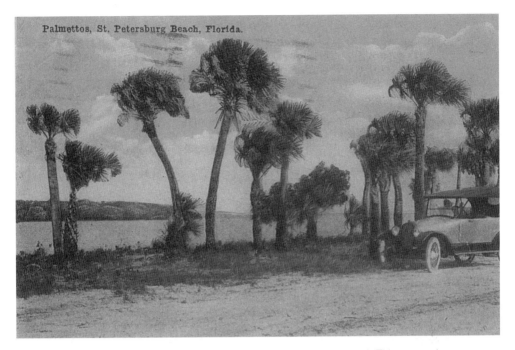

Palmettos, St. Petersburg Beach, Florida.

Palmettos are shown near the beach. Notice the car parked along the beach. This postcard was published by A.B. Archibald of St. Petersburg.

A picture of the Wever Groves Hotel with a Citrus Groves salesroom located at 46 Sixth Street South.

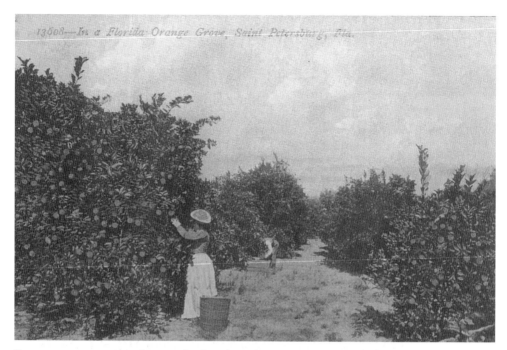

Oranges were common and postcards often showed people picking them. This image shows an orange grove in St. Petersburg with people picking the fruit.

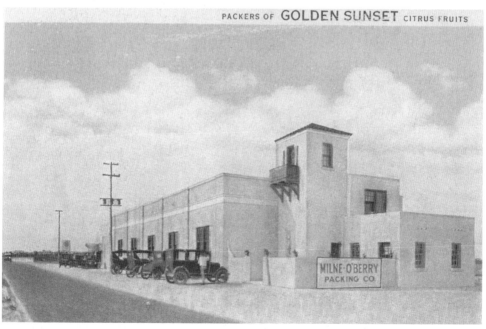

A picture of the Golden Sunset packinghouse at Seminole Bridge, which was established in 1919. This company had two salesrooms in St. Petersburg, one at 26 Second Street South and one on Sixteenth Street and Fifth Avenue North, in opposite ends of the city by 1934.

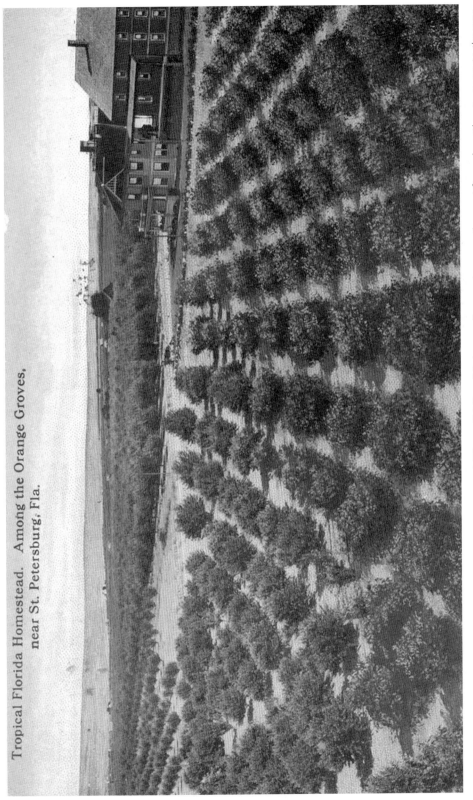

Tropical Florida Homestead. Among the Orange Groves, near St. Petersburg, Fla.

Tropical orange groves were photographed and shown on postcards. The availability of fruit was often used as an enticement for early settlers to come to the area.

Local People
and Photographs

This chapter is about the people of St. Petersburg. There were many outstanding leaders who have been documented in other histories of St. Petersburg. But in keeping with the social history, this chapter focuses on less-known people associated with St. Petersburg.

The first postcard shows three nicely dressed women sitting on a bench. A child sits in front while a black person is standing. Notice that all the women have on hats and white dresses. The boy is also dressed in white. There is a date written of 4-7-08 and it has a postmark from St. Petersburg of April 7, 1908. The back has handwriting with, "Greetings from St. Petersburg, Fla," signed Mrs. Suindler (spelling difficult to read). The postcard was sent to Ohio and is assumed to be from a resident of St. Petersburg; however, that name or one similar was not found in the city directories of that time. Therefore, we must assume the author was a tourist and the picture was made to document their visit to St. Petersburg.

On the back of that postcard is stamped in ink the name of Lyn Friedt, someone who has been recognized as a local postcard collector of the 1990s since he always stamped his name on his postcards. He achieved recognition as Preservationist of the Year by the American Institute of Architects for restoring a 1920s-era stucco house on 22 Avenue North and Highland Street. He attributed his interest in history to his grandmother who, as an early St. Petersburg resident, collected postcards from 1907 to 1940. His postcards, which he inherited from his grandmother, told the story of the city and piqued his interest in its history. This postcard had to be from his collection.

Lyn Friedt was vocal about the green benches, which he saw "as a good example of the city fathers destroying something unique to the city." He viewed "the green benches as setting St. Petersburg apart from other cities." All the green benches were gone by the 1970s as the city tried to revamp the city's image. Lyn Friedt stated in an article that, "the city lost more." He also opposed tearing down the Soreno Hotel, which was done anyway. All this shows how Lyn Friedt was involved with the preservation of St. Petersburg through historic renovations and

preservation of old postcards. He was a local person and well known as a postcard collector.

Another postcard that is not shown here but was postmarked from St. Petersburg on January 4, 1908, has a handwritten message signed Dorothy Dockett. The postcard picture shows two people, a man and woman, standing in front of some foliage with this message, "Hope you know the Crackers on the opposite side of this card." The word Cracker has often been a label given to native Floridians.

The message continued, "I am ashamed of not having acknowledged your gift sooner. Many Thanks. I went shelling before daylight yesterday morning and made a good haul. Binford's were out too. Some friends of ours from Fairmont have rented two of our rooms so we are doing the light housekeeping." This is a good depiction of some of the early activities of people in St. Petersburg.

The name Dorothy Dockett, the writer of the previous message, was not found in the city directory for that time period. She added words to a song about Florida to be sung to the tune of "Maryland, My Maryland" to the front side of the postcard. She stated that the song "was sung at the State Teachers Association here." Both sides of a postcard can be interesting even though the picture may not be significant.

A third postcard to be shown and postmarked 1910 had the following writing on the back, "Agnes Taylor, 235 7th Avenue N.E." Earlier in the city directory of 1908, Agnes Taylor lived with Dr. Jason L. and Mattie Taylor at 475 Central Avenue while W.S. Worley, a clerk, lived at 235 Seventh Avenue NE. Dr. Jason Taylor had been identified as an anesthetist at the St. Petersburg Sanitarium in the 1908 city directory. While a 1910 city directory was not available, Mrs. Mattie Taylor was identified as a widow in the city directory by 1914 and she lived at 235 Seventh Avenue NE until 1930. A photo of the 235 Seventh NE house is available and that home is still a part of the city today.

A fourth postcard shows a picture of James Earl Doc Webb who came to St. Petersburg in the 1920s and established Webb's Cut-rate Drug Company. He was a remarkable person who, during the Depression, catered to the lower end of the mass market and became a wealthy man as well as a celebrity. He was a maverick whose passionate commitment to unrestricted competition set him apart from the rest of the business community. He retired in 1974 and died in 1979.

In 1966, Doc Webb received the CONA Award for his service to the people of St. Petersburg, Pinellas County and America since 1939. A list of his achievements was included with the award. Two of those achievements consisted of Doc Webb selling over $3 million in World II war bonds and his responsibility in removing the railroad tracks from downtown St. Petersburg in 1965.

Although the railroad became the means of developing St. Petersburg in the late 1880s, by the late 1960s they had become an eyesore to the downtown. Doc Webb was credited with their removal.

A local citizen as an employee of the First Federal Savings and Loan Association wrote the following letter to Doc Webb upon his receiving the CONA Award. This letter follows with her permission:

February 28, 1966

Mr. James E. "Doc" Webb
Webb's City, Inc.
St. Petersburg, Florida

Dear Doc Webb:

I am so happy that you have been honored by CONA with a special award. There are not too many individuals in our town who believe in fighting for the rights of the "individual" and for the free enterprise system. Truly, Doc Webb, you are an "Uncommon Man" and worthy of your sale.

St. Petersburg has been blessed in many ways, and you were and are one of its biggest blessings. I heard of Webb's City long before I ever heard of St. Petersburg! St. Petersburg didn't make Webb's City-but Webb's City really played a big, effective part of making St. Petersburg.

I have followed the progress of Webb's City ever since 1945, when Mr. Raleigh Greene Senior hired me. (I am still with First Federal as advertising manager). Mr. Greene held you in high esteem.

May you live long and happily, and "at bat" for the things you really believe in.

Your admirer of long standing,
Odette W. Patterson
Hillside Drive, South St. Petersburg, Florida

Odette Patterson symbolizes local St. Petersburg citizens in many aspects. She worked at First Federal Savings for twenty-four years, retired, became a real estate agent for nineteen years and moved to Bayfront Towers in 1993. In her eighties, she established a Patterson Trust as a perpetual trust to honor those involved in police work and fire protection in the city of St. Petersburg. The Patterson Trust provided awards and scholarships for members of the city police and fire departments. She contributed back to the city that she had learned to love and became a model in giving back to the community, after years of enjoying St. Petersburg.

Doc Webb replied to Odette Patterson's letter in his own unique way. A copy of his letter on his stationery is included in this book.

An earlier picture is also not a postcard but a copied photo given to the author. It is a picture of the *Evening Independent* carrier boys taken on February 5th, 1914, in St. Petersburg, Florida. This picture was courtesy of Cathy Bideaux, a longtime antique dealer and lover of St. Petersburg history.

The carrier boys of the *Evening Independent* (a local newspaper) were identified by numbers and written on another part of the picture. The names identified on the 1914 picture were searched through the 1930 St. Petersburg directory to determine how many of the carrier boys stayed in St. Petersburg and what careers they were identified with. That information follows.

1. Harry Patrick listed in 1914 but was not in the 1930 city directory.
2. Miller Williams listed in 1914 but was not in the 1930 city directory.
3. King Chase in the picture in 1914 but was not in the 1930 city directory.
4. William Robinson. There were three William Robinsons in the 1930 city directory: William H. lived at 1321 Dunmore Avenue South and was a laborer, William A. lived at Eighth Avenue South and William O. lived at 3913 Sixth Street South.
5. George West was a carrier in 1914 and in 1930 he was married to Anna B. He was a salesman at the Fern Grill Fruit Packing Company and lived at 1010 Thirteenth Street North. He was part of the citrus industry.
6. Cloyd Kuster was in 1930 a stage carpenter for the Plaza Theatre. He was married to Beulah and lived on Twelfth Avenue South.
7. Albert Fussell was a carrier in 1914 but not listed in the 1930 city directory.
8. Garrard Williams was a carrier and in 1930 he was a salesman, living at 1021 Sixteenth Avenue North.
9. Ralph King was no longer listed as living in St. Petersburg in 1930.
10. Ralph Myers was no longer listed in the city directory by 1930.
11. Ventrus McCraven was a plumber by 1930 and was married to Genevieve, living at 2551 Fifteenth Avenue North.
12. James McCraven was listed as deceased by 1930, leaving a widow, Minnie. He had a grocery and restaurant at 832 Seventh Avenue North and his son, Hubert F. McCraven, was working in the grocery and restaurant.
13. Ferdie Thomasson was identified in 1914. In 1930 a Ferdinard W. Thomasson resided at 1900 North Shore.
14. Charlie Boyee was not listed as living in the city in 1930.
15. Lionel Arnold was not listed as living in St. Petersburg in 1930.
16. Joseph Davis. In 1930 there were three Joseph Davises listed. One was a janitor at the *Evening Independent*, residing at 1564 Third Avenue South; another was Joseph S. Davis, who was an attorney at 614 West Coast Title Building; or Joseph W. Davis, who was an office manager for Joseph S. Davis, the last two living at 4744 Fourth Avenue North.
17. William Murphy was listed twice in the 1930 directory. William J. Murphy was a fruit packer living at 908 Seventh Avenue North, or William M. Murphy living at Fifty-fourth Avenue North, a salesman at Byers-Waldrep.
18. Rex Cole was a salesman with J.B. Green Realty Company in 1930. He lived with his wife, Bernice, at 7003 Park Street South.
19. Walter Sykes was not listed as living in the city in 1930.
20. Jack A. Converse Jr. was the circulation manager in 1914. In 1930, there was a Mrs. Adela Converse living at 1927 Twenty-seventh Avenue North and a Charles N. Converse living at 2668 Eighteenth Street.

Of all the young men listed in the 1914 picture, over half were listed in the 1930 city directory. There have been many more carriers where their pictures have been lost. This picture was preserved by a person who loved the history of St. Petersburg.

It was from the *Evening Independent* that the publisher Lew B. Brown nicknamed St. Petersburg as the "Sunshine City." He agreed to give away all copies of his newspaper every day that the sun failed to shine in 1910. By 1924, the paper had been given away only seventy-one times. This offer attracted so much attention toward St. Petersburg that from an advertising standpoint, it was invaluable. The *Evening Independent* was the only paper in the world to make such an offer.

Samuel T. Johnson, in his biography at the St. Petersburg Museum written in 1992, stated that he had been an *Evening Independent* carrier in the 1920s. He had forty customers between Fifth Avenue North and Fifth Street North. He was paid one dollar per week when the paper was fifteen cents per week. The *Evening Independent* was owned by Mr. L. Chauncey with an office at Fourth Street and First Avenue South.

John Blocker Jr. also claimed that he was a newspaper boy with the *Evening Independent*. His biography is also in the St. Petersburg Museum. His father came to St. Petersburg with the Orange Belt Railroad, the first railroad line to reach what was then called the Pinellas peninsula. His father was the first engineer to work on the Orange Belt's run from Sanford in Seminole County to St. Petersburg. By 1906, his father, John Blocker Sr. established a real estate office as his son John Blocker Jr. grew into manhood. John Blocker Jr. finished law school and returned to St. Petersburg to be appointed attorney for Pinellas County for many years. He died in 1957 at the age of sixty, having been one of the early settler families. He encouraged historical preservation of the city.

While the previous electric pier had been severely damaged during the 1921 hurricane and everyone, including the fishermen, missed their pier, it was Lew Brown, editor of the *Evening Independent*, who mounted a drive to raise money for the modern, state-of-the-art recreation pier to rival Atlantic City's Steel Pier. The idea caught on after Brown received $300,000 in pledges and the city council proposed a $1 million bond issue to underwrite the new pier, and it all became history. By December of 1926, the new Municipal Pier had just been completed following a bond issue to underwrite what was later called the Million Dollar Pier.

A colored picture taken from another local paper, the *Daily News*, December 19, 1926, of the city of St. Petersburg also reflected local attitudes of wanting a new pier. The picture shows a wish fulfilled from Santa Claus to St. Petersburg and is symbolic of citizens' wishes at the time. Miss St. Petersburg is holding and admiring a new Municipal Pier while asking for more. The picture is a classic of the time.

One person who has received little attention in the history of St. Petersburg but a very prolific photographer of St. Petersburg was E.G. Barnhill. He opened his shop, called the Florida Photo Studio, in 1914, located at Third Street North and Tenth Avenue. His shop was still listed in the city directory in 1930 at that address. He began by selling postcards and colored pictures from those he made around St. Petersburg.

Before coming to Florida, Barnhill tried his hand as an Indian trader in Colorado, opening a curio shop specializing in American Indian artifacts and crafts. While there, he met and worked with renowned photographer Edward Curtis. It was Curtis who introduced Barnhill to

tinting images and to a process called gold toning. This is done by coloring the photographic images on the glass negative with special uranium dyes. When this stage is completed, the back of the glass is covered in a gold foil-like sealant, which gives it a golden glow.

As Barnhill began hand tinting printed copies of his photographs, he used the Albertype Company in New York to publish most of his postcards as uncolored prints. He hand-applied watercolors, which resulted in the rich undiluted colors common to his prints and postcards. Barnhill preferred landscapes but he did other subjects around St. Petersburg as can be seen from his following postcards.

By 1935, Barnhill was no longer listed as a photographer in the St. Petersburg city directory, but he was still registered as owning the Barnhill Camera Shop and selling photographic equipment supplies. By 1936, Barnhill was no longer in the city directories but his wife Helen owned a gift shop in the city. By 1938, Helen still owned her shop but was listed as living in Dania, Florida, and relegated the St. Petersburg business to one of her sons.

The Barnhills were listed as living in Dania, Florida, by 1938 as E.G. decided to open another Indian Trading Post similar to his first one in Colorado, this time in Wisconsin Dells, Wisconsin. This was followed by other trading posts in Booth Bay Harbor, Maine, and in Indian Springs, Georgia. He opened an attraction called Ancient America in Boca Raton, Florida, in 1953 and closed it in 1958. His final roadside venture was the Indian Museum and Trading Post in 1970 near Kissimmee, Florida. The business closed in the mid-1980s and Barnhill moved to North Georgia. He died in 1987 at the age of ninety-three.

It appears that most of Barnhill's pictures were produced from 1914 to 1930. He was a consummate blend of artist, adventurer and entrepreneur. He traveled Florida, the Caribbean islands, and Panama searching for artifacts and treasures. What began as a photographic enterprise evolved into a series of Indian trading posts to museum roadside attractions. These in turn drew the curious tourists to buy his prints, postcards and other souvenirs that collectors seek today. His postcards of St. Petersburg stand out for their beauty different from other postcards on the same subject.

E.G. Barnhill's images can be seen in the color insert after page 96.

A photo of three nicely dressed women sitting on a bench. All, including a boy child, are dressed in white and taken on one of the green benches in what appears to be a park or in an area with foliage. The black person in a suit has been identified as a possible coach driver. He was included in the picture, indicating how important he was to the family.

A picture of the Evening Independent carrier boys taken on February 5, 1914, in St. Petersburg.

A photo of the 235 Seventh Street house. Since there is no documentation of any professional photographer, the photo was made by a novice who owned a camera. After the pictures were developed at a photography shop, postcard backs were added to the photo to send through the mail. This one was never mailed. Photo postcards such as this one were one of a kind, whereas pictures printed by publishing companies were made in large numbers and sold to the public.

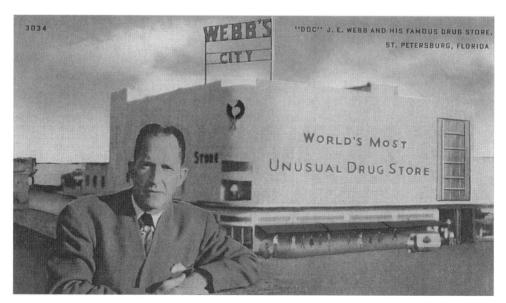

A picture of James Earl "Doc" Webb, who came to St. Petersburg in the 1920s and established Webb's Cut Rate Drug Company. This postcard was published by a Pinellas County publisher, Hartman Litho Sales Co., Largo, Florida, in the 1940–50s. Doc Webb was always advertising himself and his stores, often on postcards.

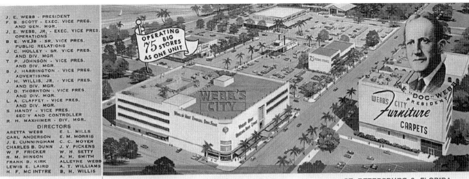

ST. PETERSBURG 2, FLORIDA

March 3, 1966

Mrs. Odette W. Patterson
732 Hillside Drive, South
St. Petersburg, Florida

Dear Mrs. Patterson:

Thank you, very much, for your nice and flattering letter of February 28th. The feeling was mutual between Mr. Raleigh Greene Senior and myself.

I can assure you that I, as well as all at Webb's City have loved St. Petersburg and will always try to do everything possible to keep it a wonderful place to live. We will always fight for individual rights and for free enterprise.

If we can ever be of help to you, please advise.

Yours sincerely,

WEBB'S CITY, INC.,

J. E. "Doc" Webb. — President

JEW/p

ANNUAL RECEIPTS OVER $30,000,000.00 · RECEIPTS 1925 . . . $38,990.45

A letter by Doc Webb to Odette Patterson dated March 3, 1966. Doc Webb's letter stationery shows his flamboyant style of advertising even on simple letters.

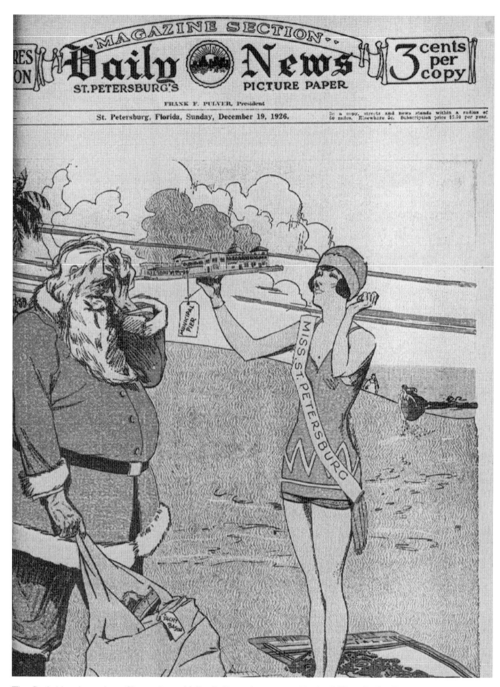

The *Daily News*'s version of how pleased Miss St. Petersburg was with the Million Dollar Recreation Municipal Pier. While she appears to be very delighted, she also appears to be requesting more items such as a municipal bus line, a Fuller Airport and a yacht basin. Santa appears to be exhausted. The picture shows the local expectations at that time. The Fuller Airport was the first airport in St. Petersburg and it was used during World War II along with two other local airports at the time. The Fuller Airport later became part of the Jungle subdivision of homes.

Military, Movies
and Music

While military does not usually fit into a chapter concerning movies and music, in St. Petersburg it does. Military personnel were often entertained by patriotic citizens who provided movies and music for the servicemen. Entertainment and relaxation were primary roles that St. Petersburg provided to the military while various forms of training developed as needed.

Part of the early social history of St. Petersburg was its emphasis on patriotism; the city started celebrating Washington's birthday as early as February 22, 1896. The celebration was held annually until 1914, as schoolchildren paraded through the business section of town. It was discontinued by the school board because they felt the parade took too much of the pupils' time. Although the parade's success was marred by Union and Confederate veterans refusing to march together, other annual celebrations did survive until 1917 when it was reincarnated into what was called the Festival of States.

The Festival of States held its annual celebration in February at the height of the tourist season. Every float or vehicle had fresh flowers and American flags. Tourists formed societies according to the state they came from and would enter a float about their state in the parade. These state societies grew as they held regular socials or excursions, returning to their home state as promoters of the Sunshine City.

Early St. Petersburg felt the impact of World War I as the Florida Naval Militia were ordered to duty in 1917. Of the 750 St. Petersburg men who served in the war, 16 died. Two of those were sailors, Harold Myers and Paul Webb from St. Petersburg, on the U.S. Coast Guard Cutter *Tampa* when a German U-boat torpedoed it.

Another military presence in St. Petersburg was noted as early as 1919 when Company G Second Infantry NGF was located at the armory on Fourth South and First Avenue. The captain was C.P Potter with a detachment of the Hospital Corps also located at the armory.

In February of that same year, the city welcomed the navy. This was the first time since the war with Germany that the navy had visited the city. The army was expected to take a back

seat. Vessels were present with 120 officers and 1,600 navy men. The city became a part of their shore leave. They were given automobile rides with dinners and musicals at the Plaza Theatre only for army and navy men. Their large boats were anchored in the deep water and visits were provided to the local people for twenty-five cents.

St. Petersburg was starting its role as a source of military recuperation and training as more wars were to come. Part of St. Petersburg's recovery role with the military was to provide movies, music and entertainment, for which the city was already well established. Therefore, it is very apropos to include these three categories, military, movies and music, together.

It was in the early 1920s that another problem developed in the area: smuggling alcohol into Tampa Bay. The Coast Guard opened a base in St. Petersburg on the north side of Bayboro Harbor, base number 21, under the command of Charles G. Roemer. This was the beginning of the Coast Guard in St. Petersburg.

The U.S. Coast Guard had 125-foot cutters and eight 765-foot long patrol boats. By the late 1920s, forty-five vessels operated out of this local base with some parking at the pier, as can be seen in a postcard.

Prohibition lasted for thirteen years. During this time, the city's eastern shoreline was radically changed with a sea walled front. The dredging of Bayboro Harbor produced a large landfill that was to become Albert Whitted Airport and the United States Coast Guard Station. After Prohibition was repealed, the U.S. Coast Guard base was decommissioned in 1933. Commander Roemer recommended that the site be used as an air rescue base.

In 1939, war was beginning in Europe and threatening U.S. shipping. American merchant seamen needed wartime training and the Coast Guard was assigned this task. Another postcard showing the Merchant Marine School in St. Petersburg, Florida, was sent by Private Glenn Gall of the U.S. Army, 603 Training Group, St. Petersburg, in 1943.

In 1942, the Merchant Marine training was assigned to the U.S. Maritime Service. Barracks were constructed on the north side of Bayboro Harbor. Those buildings can be seen in a postcard.

The training station consisted of a five-week course followed generally by either deck or engine instruction ranging from three to eight weeks. A cooks and bakers school was held aboard the ship *Tusitala*. Famous as a sailing ship of other days, the *Tusitala* was cleared of sailing gear and towed into St. Petersburg to augment class facilities for classes of theory and practical instruction in cooking, baking, butchering, care and use of tools, sanitation of cooks at sea and other ship routines. Graduation from the school in a single month peaked at 345 cooks and 511 mess men.

The *Tusitala* was a 261-foot vessel built in Greenock, Scotland, in 1883. It operated in merchant service before becoming a receiving ship in St. Petersburg in 1940.

The first training vessel attached to the United States Maritime Service Training Station in St. Petersburg was the *Joseph Conrad*. It was the last surviving frigate in the world, 165 feet long, and had trained apprentice seamen. It was built of Swedish iron in Copenhagen in 1882 and trained four thousand Danish boys during its fifty years of service under the

Danish government. In September 1939, the U.S. government acquired the ship from an American and converted it into the U.S. Maritime Service training ship stationed at St. Petersburg, Florida.

The *Joseph Conrad* served throughout World War II and sat idle for two years. An act of Congress in 1947 donated the *Joseph Conrad* to the Mystic Seaport Mariner's Museum at Mystic, Connecticut. Since that time, the old ship has been used in Mystic's youth training program.

Other training ships manned at the Maritime Service Training Station included steamships the *American Seaman, American Mariner* and *American Sailor*. The *American Sailor* carried 250 trainees in addition to the regular crew of eighteen officers and one hundred enlisted men. Four complete machine shops, various lifeboats and up-to-date navigational equipment comprised the special educational equipment. A postcard shows seamen learning endurance swimming, abandon ship drills and boarding a lifeboat before lowering it into the water on some of those vessels.

The Bayboro Maritime Base continued to train a small number of merchant seamen until it became the Bay Campus of the University of South Florida in 1965. The Old Maritime Service barracks now house the University of South Florida at St. Petersburg Department of Marine Science and the Florida Institute of Oceanography. There is a monument erected in honor of the training center with the following, "Here trained more than twenty-five thousand volunteers for America's Merchant Marine during World War II."

The city was a natural for all military services during World War II, including the army and its air corps. The climate was mild and stable and there were abundant hotel rooms. Two airports were available in the area, the Albert Whitted and Pinellas County Airports with a third private one, the Piper-Fuller, activated mostly for trainer planes. Two other airports were in Tampa. By spring 1942, the Army Air Corps had around ten thousand men and doubled by fall as they served to train pilots in the St. Petersburg area.

The War Department had elected St. Petersburg as a major technical services training center for the Army Air Corps. More than one hundred thousand trainees and instructors passed through the city during this period. The main training facilities in Pinellas County were the Albert Whitted Airport and the County Airport, a much bigger training facility.

The Civil Air Patrol began operation on December 1, 1941, as individuals were activated to protect the Florida coastline. Women were encouraged to join and Ruth Clifford, with strong aviation interest, trained as a WASP and tested airplanes for any problems. She was a founding member of the Civil Air Patrol and symbolic of many local citizens helping with the war effort.

Of St. Petersburg's dozens of hotels, only one remained available for commercial guests while others were full of military soldiers during World War II. As each wave of soldiers stayed from four to six weeks, replacements moved in and the number of military personnel reached 120,000 during the war. That figure did not include the thousands at MacDill Field in Tampa, many of whom used their weekend passes in St. Petersburg and the Gulf beaches.

Within hours after Pearl Harbor, the Don Ce Sar Hotel on Pass-a-Grille was flooded with cancellations. The 252nd Coast Artillery Battery occupied Pass-a-Grille, taking over most of

the community's dwellings and establishing defenses. Anti-aircraft guns, observation towers and tent camps were constructed. In the summer of 1942, the army condemned the hotel and bought it for its assessed value of $460,000. These actions gave Pass-a-Grille the distinction of having military bases on both ends of the town. Few towns of less than four hundred people can match that.

By December of that same year, the Don Ce Sar was a hospital for the St. Petersburg basic training center. But the new hospital was soon too small to handle approximately eight hundred sick calls per day. When the basic training center closed in the midsummer of 1943, the Don Ce Sar became a sub-base hospital for MacDill Air Force Base in Tampa. In February 1944, it became the Army Air Force Convalescent Hospital.

In June 1945, with the war in Europe over, the Don Ce Sar Hospital was deactivated and the hotel was reopened in 1973. It went through several renovations and is still open as a hotel.

After the war, Ruth Clifford was an airplane instructor at Albert Whitted airport where she met Pete Hubert and married. She raised two children and became a widow in 1962. She returned to flying and continued to serve in the Civil Air Patrol. Her service to her country has continued to be an outstanding example of citizen involvement with aviation. She has received many awards for her accomplishments.

Another military hospital already established in Pinellas County and used during World War II was the Bay Pines Veterans' Administration Hospital located at Long Bayou on Boca Ciega Bay, northwest of St. Petersburg. It was actually created in 1932 as a much-needed boost for the local economy during the Depression. Several buildings have been added to the facility over the years and it has continued to be used as a hospital. A picture of that facility is on a postcard. Its beauty is evidenced by the presence of trees and foliage. Notice three people fishing, both in the traditions of St. Petersburg.

Military training for younger people was a part of the St. Petersburg history. The Florida Military Academy provided military training from 1932 to 1951 when it occupied the previous Rolyat Hotel. The Rolyat Hotel had been built in 1926 and closed in 1927 as the real estate crash came. More information about this hotel is in chapter three and in the E.G. Barnhill inserts. The Rolyat Hotel, then Florida Military Academy until 1951, became the home of Stetson College of Law in 1954 and has continued to be a prominent source of legal education into the twenty-first century.

Enrollment in the Florida Military Academy reached three hundred during World War II. Contrary to how deeply St. Petersburg was involved with the war efforts, it was rapidly demilitarized after the war. All the hotels of St. Petersburg returned to civilian use.

The Pinellas County Airport reverted back to county ownership and commercial operation was started. As many as nine airlines served the County Airport, later called the St. Petersburg-Clearwater International in the 1950s. The Tampa International became the region's dominant civilian airport after the 1950s as the St. Petersburg-Clearwater International Airport continued to provide limited air service.

The Coast Guard continued to maintain a peacetime facility at Bayboro Harbor while using the Albert Whitted Airport for search and rescue missions. In 1976, the Coast Guard Air Station

of St. Petersburg was commissioned to have forty-one acres next to the St. Petersburg-Clearwater International Airport. This shifted the air station from the Albert Whitted Airport to a new and larger site while the Coast Guard station continued on St. Petersburg's waterfront, where it had been since 1933.

The Coast Guard Air station at St. Petersburg-Clearwater International Airport became the largest in the United States by 1992. It was facing a big squeeze, as hangars were crammed. There were 453 search and rescues for the previous year as helicopters were assigned for drug interception duties and aircraft was used for illegal immigrants. While the oldest Pelican helicopter in the county was located at this Coast Guard Air Station, the aging fleet of twelve Pelican helicopters was being replaced with new H60 helicopters. That expansion program was completed in 1995.

The first recorded movie theater in St. Petersburg was opened by Bill Carpenter in 1905, called the Royal Palm Theater. It was located at 247 Central Avenue. Moviegoers could see Charlie Chaplin or Mary Pickford for ten cents and children paid five cents. Bill Carpenter sold the Royal Palm Theater in 1916. He had a large caged alligator to attract patrons to the Royal Palm Theater. He also owned a curio shop west of the Detroit Hotel with one thousand baby alligators in pens behind the store. He shipped live alligators all over the country, guaranteeing them to be alive on arrival.

Bill Carpenter went into the real estate business after selling his theater. He organized the St. Petersburg Board of Realtors, of which he was an active member for more than fifty years. He died in 1973 at the age of ninety-one.

In 1913, George S. Gandy opened the La Plaza Theatre with the production of *Il Trovatore* by a Royal Italian Company. He paid $150,000 for the 1,800-seat facility. In 1920, it became a movie house and it was acquired by Florida State Theatres in 1948. It is shown on a postcard as the Plaza Theatre. After years of being the centerpiece for St. Petersburg culture and entertainment, the La Plaza Theatre was demolished in 1957.

St. Petersburg's Florida Theater was the first to open with air conditioning in 1926. Previously, all theaters were closed during the summer months. The Florida Theater was located on the northeast corner of Central Avenue and Fifth Street. The theater was built to be reminiscent of a castle in Spain. It continued as a landmark with Elvis Presley performing there in 1956. The Florida Theater had 2,300 seats, nine dressing rooms, a rooftop garden and towering interior walls covered with suits of Spanish armor, tapestries and other works of pseudo-Renaissance elegance. It was demolished in 1968, leaving a void in downtown entertainment.

The downtown movie theaters did not return to St. Petersburg until after nearly forty years of absence. Plans were initiated for a development called BayWalk, with three blocks of retail and entertainment, including twenty movie theaters, at the beginning of the year 2000.

While the theaters provided their brand of music and entertainment, band music had also been a part of the city, starting in Williams Park. Williams Park, established since 1888, was the community's center in the early 1900s. Band music was provided on a regular basis in Williams Park. In 1917, a patriotic celebration took place in Williams Park as St. Petersburg

prepared for war and bands played in the bandstand. In 1918, following a parade, four to five thousand people gathered in Williams Park for a celebration in songs and band selections following the signing of the armistice with Germany. Band music as a part of Williams Park can be seen in several postcards.

A Sunshine City band played often in the Williams Park Bandstand as early as 1913. The Royal Scotch Highlanders Band started in 1917, returning every season until 1927. Major Everett A. Moses brought his band to St. Petersburg in 1928 and they played each season until 1940. His style and individuality embodied wide diversity. Mr. Moses, called the originator of the modern style of band entertainment by metropolitan critics, is pictured with his band at Williams Park.

Starting in 1948, Joseph Lefter and his band played in Williams Park for the next thirty-three years, creating a tradition for the old-timers of St. Petersburg. He was to St. Petersburg what Arthur Fiedler was to Boston.

Originally, the band played thirteen concerts a week during the season but through the years, as times changed, concerts in Williams Park lost their attraction and funds were cut by the city. Concerts became available only once a day and finally went down to once a week until St. Petersburg's Music Man, Joseph Lefter, retired and the interest was gone. A postcard shows how well attended the concerts were in Williams Park.

The first bandstand in Williams Park was completed in 1895, following a fence around the park to keep wandering cows and hogs from entering the park to graze. The first bandstand was replaced in 1920 by a second one, shell shaped, which can be seen in a postcard.

This second bandstand was later replaced by a third current one and has often been used for many other purposes beside band concerts. In 1980, presidential candidate Ronald Reagan held a rally in the third bandstand at Williams Park that 5,500 people attended, all showing the diversity that Williams Park has provided during the years to the city of St. Petersburg.

A postcard shows the U.S. Coast Guard at what was called Bayboro Harbor. That was the beginning of the presence of the Coast Guard in St. Petersburg.

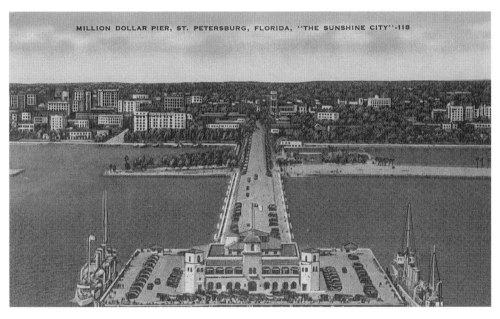

The U.S. Coast Guard had some 125-foot cutters and eight 765-foot long patrol boats requiring space to store them. By the late 1920s, forty-five vessels operated out of the local base with parking at the Million Dollar Recreation Municipal Pier being used for the larger vessels. Two vessels can be seen parked at the Pier.

A postcard sent by Private Glenn Gall of the U.S. Army, 603 Training Group, St. Petersburg, in 1943 shows the U.S. Maritime Training Station in St. Petersburg. He sent the postcard to Mr. Willim Freshley at South Bend, Indiana. He wrote an encrypted message that appears to be in code or of special meaning to his recipient. This being wartime, such encrypted messages on postcards were not that unusual.

The U.S. Maritime Service assumed responsibility for the Merchant Marine training in 1942 and constructed barracks on the north side of Bayboro Harbor. This picture was identified as an official photograph by the U.S. Maritime Service. The *Sun News* of St. Petersburg published this postcard.

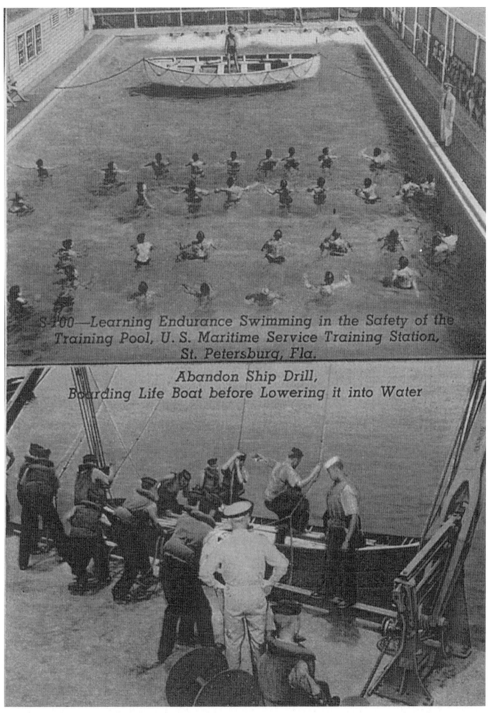

S-100—Learning Endurance Swimming in the Safety of the Training Pool, U. S. Maritime Service Training Station, St. Petersburg, Fla.

Abandon Ship Drill, Boarding Life Boat before Lowering it into Water

The training of seamen included endurance swimming, abandon ship drills and boarding lifeboats. The picture was again identified as an official photograph by the U.S. Maritime Service and published by *Sun News.*

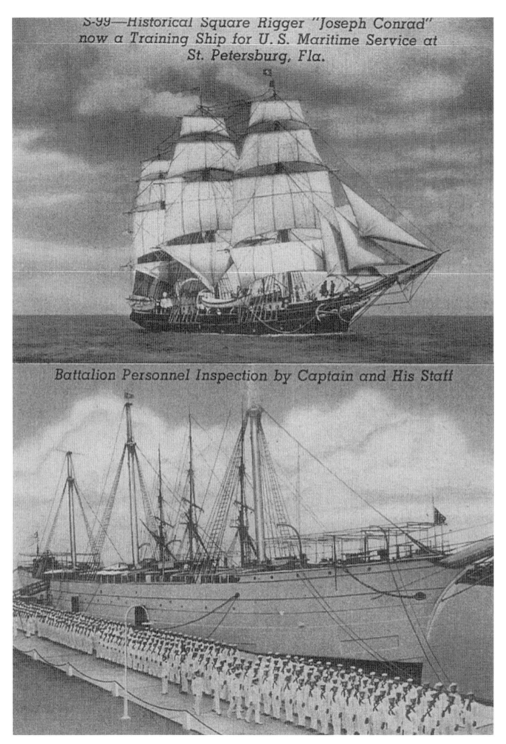

S-99—Historical Square Rigger "Joseph Conrad"
now a Training Ship for U. S. Maritime Service at
St. Petersburg, Fla.

Battalion Personnel Inspection by Captain and His Staff

The *Joseph Conrad* on the top half of the picture. The bottom part of the image shows the battalion personnel inspecting the *Joseph Conrad*. The pictures were identified as an official photograph by the U.S. Maritime Service. The *Sun News* of St. Petersburg published this postcard.

An image of the Army Air Corps. They trained mostly at the Pinellas County Airport but two other airports were also available in the St. Petersburg area during World War II. The photography was photographed by the Army Air Corps but it was published as a tropical Florida Series.

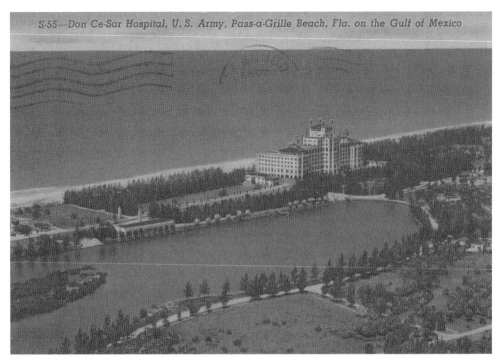

A postcard showing the Don Ce Sar, located on Pass-a-Grille, as a U.S. Army Hospital.

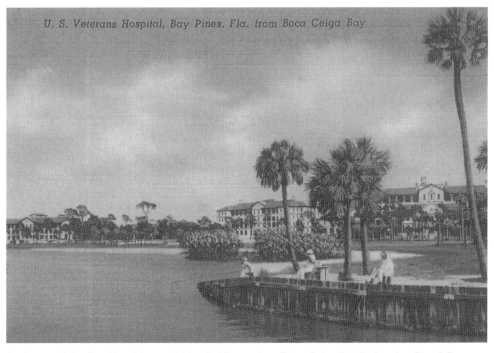

An image of the Bay Pines Veterans' Hospital located on Boca Ceiga (spelled today, Ciega) Bay.

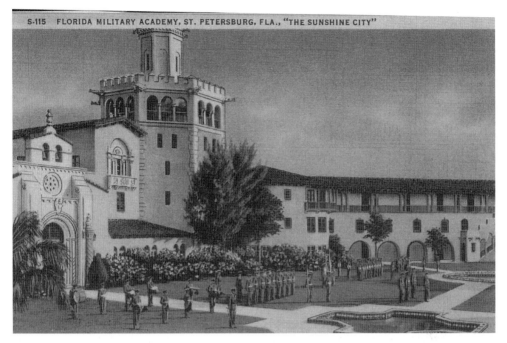

S-115 FLORIDA MILITARY ACADEMY, ST. PETERSBURG, FLA., "THE SUNSHINE CITY"

The Florida Military Academy provided military training from 1932 to 1951. While the young men are marching in this picture, the background of the postcard emphasized the Spanish architecture in the five buildings.

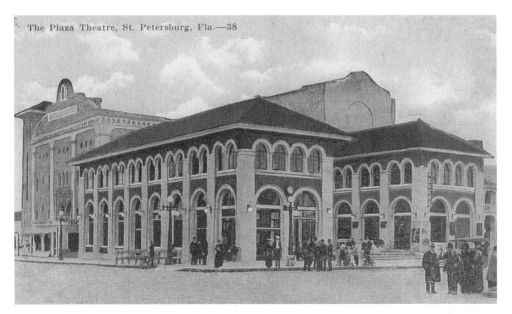

The Plaza Theatre, St. Petersburg, Fla.—38

A picture of the La Plaza Theater. While the postcard identifies the La Plaza Theater as the Plaza, such was not really documented in other historical sources. The picture is correct but the name change was not used in other sources, showing how careless postcard publishers could be.

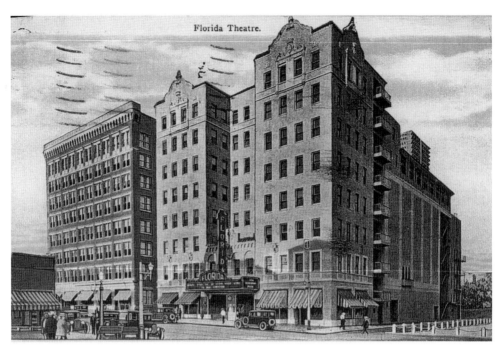

A picture of the Florida Theater. It was advertised as "a new million dollar public theatre, with a cooling system in this theatre keeps temperature at 70 degrees." Odette Patterson often recalled to this author how she and friends would go to this theater in the hot summer just for the cool temperatures, a real novelty at the time.

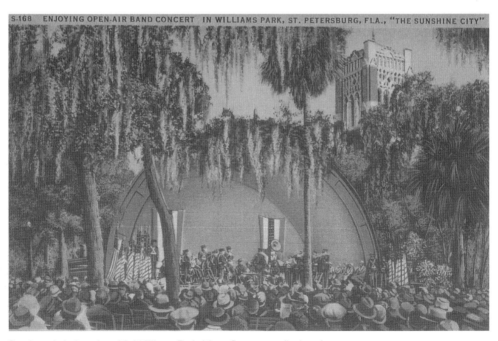

Band music being played in Williams Park. Many flags were displayed.

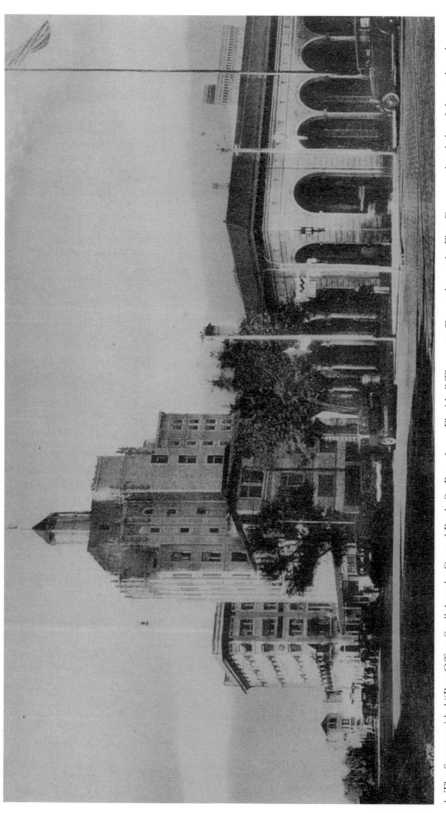

1. The first was titled "Post Office, Snell Arcade, Central Bank, St. Petersburg, Florida." The post office replaced the First Congregational church located on the southwest corner of First Avenue North and Fourth Street in 1916. It was Ed Tomlinson's unique design that was used to create this open-air post office in 1917; it has become a city landmark. The Snell Arcade Building replaced Mitchell's Corner Real Estate Office at Fourth Street and Central in 1907. In the late 1920s, the towering Snell Arcade was built for the real estate firm of Perry Snell, who was St. Petersburg's most important boom-era developer. He started building elegant homes in the northeastern section of the city as early as 1909. The Central Bank was located at the southwestern corner of Central and Fourth. That building was later changed to First National Bank and underwent several reorganizations since that time.

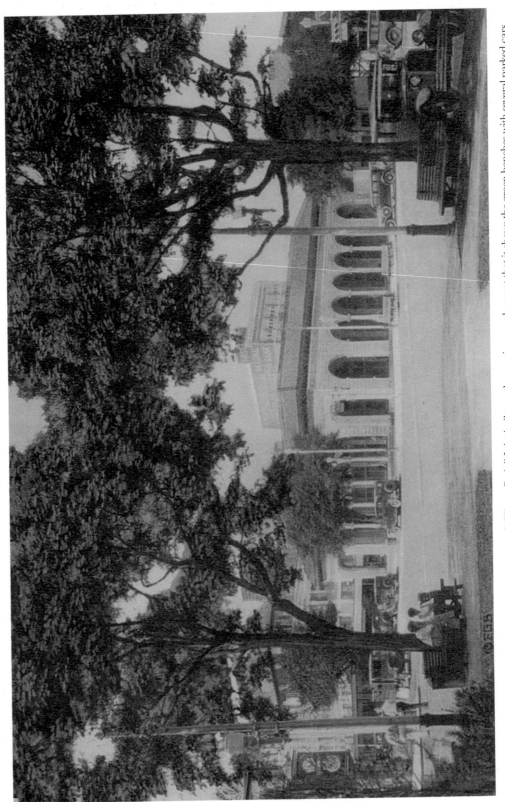

2. A second Barnhill postcard was titled "Post Office from Williams Park." It is similar to the previous card except that it shows the green benches with several parked cars.

3. The third Barnhill postcard shows the Hotel Rolyat as it looked when it opened in 1926. The hotel was created by Jack Taylor to show an image of high-class luxury; he never seemed to worry about money when he came to St. Petersburg in 1921. In the fall of 1926 when the economic bust came, he was the first to fall and he quietly slipped out of town to avoid unpaid creditors and abandoned employees. He never returned to St. Petersburg and his beloved Rolyat Hotel became the Florida Military Academy. Later in 1954 it became the home of Stetson College of Law.

4. The fourth Barnhill postcard was titled, "Royal Poinciana Tree, St. Petersburg Florida," typical of foliage discussed in chapter four. Notice the old car parked in the driveway.

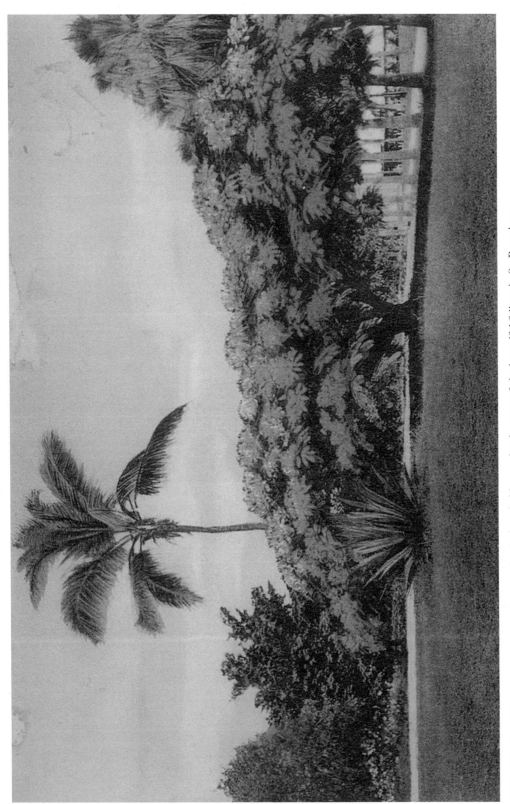

5. The fifth Barnhill postcard shows another royal poinciana in bloom, simply more of the beautiful foliage in St. Petersburg.

6. This next Barnhill postcard was titled "Begonia in Bloom" as part of a Florida Flower Series. While this postcard represents beautiful foliage present in St. Petersburg, it is different from the others in that it was printed in Saxony and was part of a whole Florida Flower Series.

7. The next Barnhill postcard was published by Man of the Mountain, a different publisher than the previous ones. This postcard is not titled nor did it have his name on the back, as Barnhill often did. It is a cute picture of a girl picking beautiful flowers.

8. The next Barnhill postcard is the shape and size of a postcard but does not have a title or postcard back. Barnhill did put his initials on the front of the picture. The picture is of two women sitting on the beach.

9. The next card signed by Barnhill is the size of a note card rather than a postcard with an unidentified publisher or title on the back. Barnhill's initials were on the front of this appealing picture showing a cute girl and beautiful foliage of the area.

10. The next card is similar in size to the previous one. There are no identifications on the back. It is a very appealing picture of a child carrying an umbrella on the beach.

11. The next two Barnhill postcards are different from the previous ones. They are pictures of houses at Roser Park. This one is titled "Roser Park." The park was named for Charles Roser, the Ohio-born cookie manufacturer who gained fame as the developer of the Fig Newton. After selling out to the National Biscuit Company, he resettled in St. Petersburg. By 1914, he had bought several dozen lots along picturesque Booker Creek and created a small high-quality residential area.

12. This Barnhill postcard was titled "A Flame Vine Arbor in Roser Park, St. Petersburg, Florida" and shows the beautiful foliage in Roser Park. This postcard and the previous one were both identified on the back in E.G. Barnhill's usual manner. These two postcards with all the others reflect Barnhill's diversity.

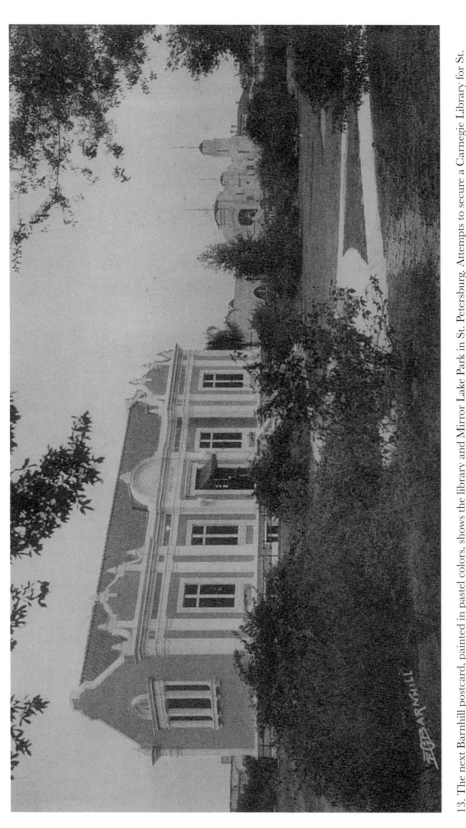

13. The next Barnhill postcard, painted in pastel colors, shows the library and Mirror Lake Park in St. Petersburg. Attempts to secure a Carnegie Library for St. Petersburg were launched in 1908. A sum of $12,500 was offered to the city by the Carnegie Corporation, but it was considered insufficient. The appropriation was increased to $17,500 after W.L. Straub, armed with a mass of letters and Sunshine City literature, visited the corporation in New York. The library was opened in 1915 and has provided continuous community service. It has since been enlarged and other libraries added to a system of city libraries. The Coliseum can be seen in the background but it was not mentioned in Barnhill's title of the card. The Coliseum was opened in 1924 as one of the nation's busiest dance halls. The Coliseum has always been immensely popular and it is still used for various social functions.

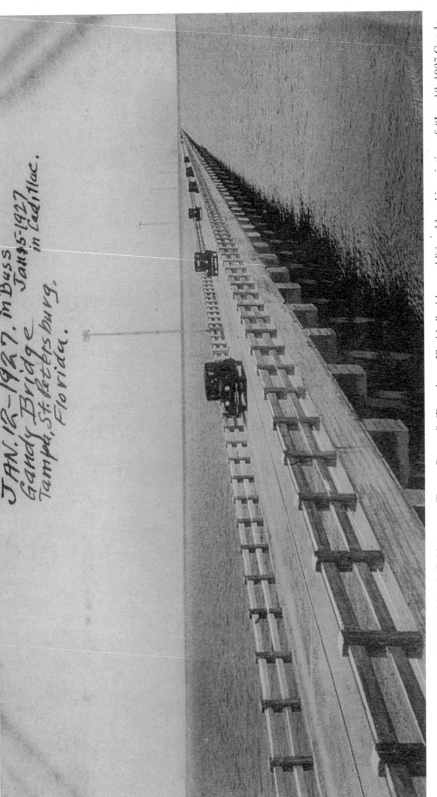

JAN.12-1927. in Buss
Gandy Bridge Jan.15-1927
Tampa, St. Petersburg. in Cad,11ac.
Florida.

14. The next Barnhill postcard is titled "Gandy Bridge across Tampa Bay to St. Petersburg, Florida," with an additional hand inscription of, "Jan. 12, 1927 Gandy Bridge, in Cadillac, Jan 15, 1927." George Gandy had plans to build the long-awaited bridge since 1910 but his project was not considered until the building boom of 1922. He convinced hundreds of investors to become Gandy Bridge stockholders and began construction that year. It was opened in November 1924. The motoring distance between St. Petersburg and Tampa was reduced from forty-three to nineteen miles once the Gandy Bridge was opened. More than any other single development, this added to the rising boom of real estate prices up to that time was the Gandy Bridge opening. It triggered an explosion of residential developments on the northern edge of the city. Real estate agents and entrepreneurs scrambled to take advantage of the skyrocketing prices.

15. This Barnhill postcard shows the bridge leading to the Million Dollar Recreation Municipal Pier. It shows the early cars going to the recreation pier. It was a popular location for tourists and fishermen.

16. This last Barnhill postcard shows a landscape view of the Million Dollar Recreation Municipal Pier taken from the land looking east towards the water. It was done in gold tones. The postcard was titled "Moonlight on Tampa Bay." The gold tone added to this landscape view is typical of E.G. Barnhill.

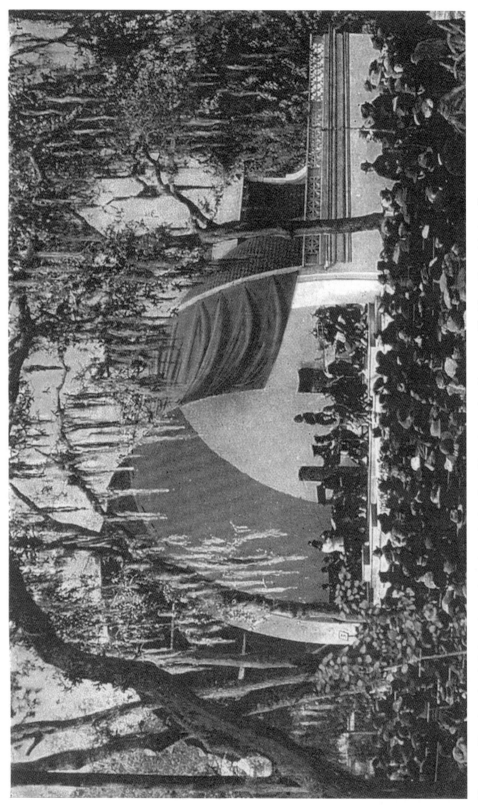

The second bandstand, a shell shaped one, shows how the bandstand has changed and been modified from the original pavilion.

A postcard shows how well the concerts were attended in Williams Park. A writer on the back of the postcard talked about the nightly concerts and "they had a singer too."

Mr. Moses, called the originator of the modern style of band entertainment, is pictured with his band.

Real Estate Developments and Agents

S t. Petersburg has had several booms and busts in real estate development, starting in 1900 when St. Petersburg only had a population of 1,575, according to the Federal Census. That was six times more than the population in 1890 and the town area was twice the size of the original 1888 plan. The town was in the midst of a major building boom with carpenters' hammers being heard from one end of the community to the other. Scores of homes were under construction; one of the grandest was Tomlinson's late Victorian "palace" located at the corner of Fourth Street and Second Avenue South.

Edwin H. Tomlinson was a Connecticut-born philanthropist who had made a small fortune in mining. He had been a winter resident of St. Petersburg since 1891. He financed several local institutions and became a fixture in the town's annual Washington's Birthday celebrations. Some of those celebrations occurred at his home. Tomlinson's home was sold to Judge Sibley and was commonly photographed. Tomlinson's house had an unusual tower, called the Tomlinson Tower, which can be seen on a postcard. There had been many postcards made of that house showing what was left of the tower.

While traveling in Italy in 1898, Edwin H. Tomlinson met Guglielmo Marconi, the inventor of the wireless telegraph, and expressed interest in Marconi conducting experiments in Florida. Marconi never came to Florida and the tower was reduced by lightning six months after the house was completed in 1901. Tomlinson was an unforgettable character who left his imprint on the local community in many ways; one of these was that he owned the first automobile in town, an Orient that sputtered along Central Avenue at six miles an hour. He was also involved with finding the Fountain of Youth.

By 1907, the local population was still under three thousand with several middle or upper class families with working classes of whites, blacks, businessmen, real estate promoters and tourists, all constituting distinctive sub-communities. The city had grown around Central Avenue, with most homes being built of wood and large porches surrounded by fruit or decorative foliage.

During the national economic panic of 1907, some Florida empires collapsed. F.A Davis of St. Petersburg lost his local holdings consisting of the trolley line, the power plant and the electric pier. They were placed in receivership and the management was turned over to another newcomer, H. Walter Fuller, destined to become a real estate mogul of the first order.

Fuller was entrusted with Davis's holdings because he had experience with operating a small electric streetcar system in Bradenton, not because he was a conservative businessman. Instead, he was a gambler who stretched his resources to the limit. With financial backings, he increased the length of St. Petersburg's trolley system from seven to twenty-three miles, acquired several new steamships and purchased thousands of acres of real estate. After buying much of the southwestern corner of the Pinellas peninsula, Fuller extended both Central Avenue and the streetcar line all the way to Boca Ciega Bay. H. Walter Fuller laid the foundation for a massive expansion of the city to the Gulf and triggered the city's first real land boom, lasting from 1911 to 1914. All of Fuller's activities led to bankruptcy and temporary disgrace in 1917. Within a year after World War I, H. Walter Fuller recovered and made several more fortunes.

While Fuller's sprawling real estate empire was a class by itself, he was no match for Noel A. Mitchell, St. Petersburg's self-styled "Sand Man." Both were masters of mass-orientated real estate promotion. By 1907, Noel A. Mitchell was selling land out of his real estate office, called Mitchell's Office, at the junction of Fourth Street and Central Avenue. He specialized in beachfront lots, including Pass-a-Grille. He made a fortune before the market collapsed during World War I. A master at developing advertising gimmicks, he used everything from motion pictures to picture postcards to sell his real estate.

H. Walter Fuller created a subdivision in St. Petersburg's West End called the Jungle and a shopping center called Jungle Prada. A country club and golf course were added to that subdivision. A postcard shows a house built in the Jungle subdivision. The home was called Jungle Manor, next to the water on Boca Ciega Bay.

In 1920, H. Walter Fuller erected a sign that marked his Jungle Subdivision as the location where the Spanish explorer Panfilo de Narvaez arrived in central Florida in 1582. The exact location of Narvaez's landing was debated among archaeologists and historians, while others saw Fuller's claims as publicity attempts to promote his subdivision.

The historical significance of the Jungle area is still being debated as late as 1994 in the *Tampa Tribune*, a local newspaper. Activists opposed razing buildings in the Jungle area for upscale townhouses because they believed that an Indian burial mound would be destroyed if the area were built over and destroyed. Others feel the site should be developed into an American Indian Museum since the property to the south of 1700 Park Street North is now recognized as the site where explorer Panfilo de Narvaez landed in 1528. The townhouses were not built but neither was the museum.

Either Noel Mitchell or H. Walter Fuller could have used a Pass-a-Grille postcard to sell the land, as both developers sold land at Pass-a-Grille and had postcards printed of their land. A Pass-a-Grille postcard shows two houses and a flowing well, possibly to advertise the area.

While H. Walter Fuller and Noel Mitchell were the early masters of mass-oriented real estate promotion, C. Perry Snell was the major developer of upscale developments. He was

born in Bowling Green, Kentucky, and operated a successful Louisville drugstore. He married a wealthy heiress who bankrolled his growing interest in real estate development. By 1904, Perry Snell and his wife had moved to St. Petersburg and within a year, he had formed the Bay Shore Land Company. Snell's new company developed two large subdivisions as the beginning of the North Shore development. With Snell nearly monopolizing the northern development by 1911, and with Fuller and Mitchell buying up large portions of the western half of the Pinellas peninsula, smaller developers had to look elsewhere.

The long neglected areas began to fill up. On the south side, the grandiose plans of C.A. Harvey were cut short by his death in 1914, but others soon picked up the slack. Charles R. Hall, who began his St. Petersburg real estate activities in 1912, developed two west-central subdivisions and cleared land to become Lakewood Estates.

St. Petersburg separated from the county government of Hillsborough, Tampa creating its own county in 1911, called Pinellas. It expanded to Seventeenth Avenue South or Tangerine Avenue in 1914 and north to Twenty-second Avenue as H. Walter Fuller expanded his Jungle subdivision on the west side overlooking Boca Ciega Bay.

Charles Roser, the Ohio-born cookie manufacturer of the Fig Newton, sold to the National Biscuit Company in 1910, resettled in St. Petersburg and turned his attention to real estate. By 1914, he had bought several dozen lots along the picturesque Booker Creek, with the intention of creating a small high-quality residential area.

There have been many postcards of Roser Park to survive, indicating that there were many produced. The first Roser Park postcard shows the banana trees in Roser Park along Booker Creek with people on the road. Fruit trees were highly photographed on St. Petersburg postcards.

A second Roser Park postcard shows beautiful foliage on a road in Roser Park. It was published by the E.C. Kropp Co. of Milwaukee.

The third Roser Park postcard shows the beautiful foliage and view of the drive in the park. A bridge over part of Booker Creek is also visible.

By 1920, the city had tripled in size with a population of 14,237 while the surrounding county, Pinellas, had a larger population of 28,265. A later postcard is about Pinson's, a real estate office located at 685 Ninth Avenue South, showing their new home in Roser Park overlooking Booker Creek. The postcard's backside had facts about the Sunshine City of St. Petersburg, claiming that there were 28,128 homes with 49 percent owned by occupants, with twenty-two elementary schools, four junior high schools and one accredited senior high school. There was one junior college. These facts fit what was true for the late 1920s.

Another postcard is an advertisement by F.E. McArthur, an owner at the corner of North Ninth and Euclid Boulevard. McArthur is advertising "a home in Bungalow Town" in St. Petersburg. He was selling lots at moderate prices with bungalow homes either furnished or unfurnished. The bungalow house market had taken root in St. Petersburg and that market continued to grow.

Two more postcards advertising homes are about one-third the size of regular postcards. They show examples of the bungalow houses in Davista. One, the "Spanish Mission Bungalow" and the other, "Sunshine Bungalow," were small postcards published by the St. Petersburg Investment Company. One card had printed on the back, "some unique and pretty home

effects have been obtained at Davista. The territory readily lends itself to beautification." The second card stated, "Note unusual effects obtained with waters of Boca Ceiga [now spelled Boca Ciega] Bay in background."

Davista was a sprawling subdivision that lay fallow after F.A. Davis's death in 1917. Jack Taylor purchased the subdivision late in 1921 and made plans to make it into a subtropical showplace to rival the most opulent developments in Florida. It was to be called Pasadena-On-the-Gulf. He did succeed at completing the Rolyat Hotel in 1926 next to this subdivision but he left town after the stock market crash that year, owing many creditors and employees. The area was later developed into the town of Pasadena, around Gulfport.

While Perry Snell was a class by himself, he was not the only north side developer to bring imagination and flair to the upscale market. Beginning in 1921, John B. Green turned an orange grove west of Ninth Street North into a subdivision called Euclid Place, an exclusive subdivision featuring large stucco and tile homes in a variety of styles, from prairie to Mediterranean and colonial revival. John B. Green continued to be a well-known real estate agent for many years and his office was located in the First Federal Savings and Loan building.

Many years after John B. Green's death, I purchased a postcard collection of his wife's. It contained around 130 postcards of friends who traveled and sent postcards to John B. and his wife, May Williams Green, from 1904 to 1980. While the collection did not contain any St. Petersburg postcards, it did reveal interesting personal information about them and their home locations during the years. In 1947, Mr. and Mrs. Green were living at 2136 Coffee Pot Drive, part of the North Shore development. In 1964, they were living at 1375 Snell Harbor Drive, again in the North Shore area. By 1980, Mrs. Green was living at Bayfront Tower. While the postcard collection revealed many friends, family and nothing about St. Petersburg, Mrs. Green saved the postcards for reasons known only to her.

Cade Allen created an even grander subdivision, known as Allendale. He was a former brick mason from New York who turned to dairy farming after his arrival in St. Petersburg in 1912. He built a cluster of high-quality homes on 160 acres of farmland that he had purchased in 1922. Cade Allen became one of the first developers in Florida to use stone as a building material.

The development of Snell Isle, Allendale and other boom time subdivisions altered the size and shape of the city in the late 1920s. The city expanded from 11.05 to 53.22 square miles.

Another subdivision, Arlington Terrace, was advertised on two postcards. This subdivision was located on Second and Third Streets between Fourth and Fifth Avenues South. Arlington Terrace was listed in the city directory as early as 1920, when it had only three homes, occupied by Dr. Harry Putman at number 201, Mrs. Reinhart at 243 and A.C. Mac Broom at 255.

By 1929, Arlington Terrace had increased to four more homes with number 211 occupied by Mr. Ed King, 219 by Mr. Van Wagenon, 227 by Almet Power and 263 occupied by Edith Whitehouse. Two of the previous homes had changed, with 243 occupied by Lawrence Latimer and 255 by L. Clifford. The subdivision was absorbed by downtown business and the University of South Florida expansions as the city grew over the years.

In the *St. Petersburg Daily News* of December 17, 1926, there was advertised a four-room bungalow on a paved street for $4,000 and a seven-room, two-story home listed for $9,000. Another bungalow with five large rooms, a bath, fireplace and enclosed sleeping porch with deep lawn and shrubberies on Sixth Street North was listed for $7,500.

The Florida real estate market crashed in 1929 and many saw their fortunes gone once again. One such man, Mark Dixon Dodd, who had moved to St. Petersburg in 1925, taught art classes and designed homes. He lost his two local houses on Tenth Avenue North in 1929. He paid his family's bills with oil paintings until he gained some major commissions to paint murals for income. From 1937 to 1941, he designed houses for a new subdivision carved out of the woods on the north shore of Big Bayou, called Driftwood. When the United States entered World War II and the building trade was halted, Mark Dodd was once again forced to look for other means of income. He operated a local motel and continued to paint. He purchased a home after World War II at Fourth Street and Fifty-fourth Avenue South with an art studio. He finally achieved national prominence for his murals and designs, some of which were in homes in the Driftwood subdivision.

Prior to World War II, R.W. Greene, president of the First Federal Savings and Loan Association, wrote letters that can be found in the St. Petersburg History Museum. He wrote many of these letters to encourage more home ownership in St. Petersburg. In one letter, he stated that building permits in 1937 exceeded 1936 and he expected real estate values to exceed a 20 percent increase. R.W. Greene stated that First Federal Savings and Loan maintained a complete building service including expert construction supervision and a service to save money. House plans and estimated costs were included with the letters. Many homes were built as a result of the efforts of R.W. Greene and his company.

By 1940, the city had a population of 60,812, sixty times larger than it was in 1900, and Pinellas County had a population of 91,852. Building did stop as World War II started and the city became very involved in the war efforts.

The first 1940s home postcard had the City of St. Petersburg logo on it and advertised the city as having beautiful homes with broad streets and attractive public parks. Notice the beautiful trees, foliage and red tiled roofs pictured, typical of the time.

The second 1940s home postcard shows an attractive home on Snell Isle, a much more prestigious waterfront residence than Roser Park. Developer Perry Snell had dredged and filled along North Shore Park to build homes on Snell Isle, with 38 acres added to the city limits. After Snell Isle was completed, it encompassed some 275 acres.

St. Petersburg attracted thousands of veterans after World War II, sparking a major postwar building boom. This postwar building boom based on housing needs was even larger than the boom of the 1920s that was based on the sale of empty lots.

As the major building postwar boom came to St. Petersburg between 1943 and 1946, the number of homes and apartments under construction rose from 11 to 1,533. Each year brought further expansion. By 1950, the number of units under construction were 3,434 as the need for housing increased. The city's population was 96,738 and Pinellas County was 159,249, both much larger than at any time previously.

The predominant styles of the 1920s and '30s of sprawling Mediterranean revival, southern revival creations to California-style bungalows were replaced with mass-produced one-story tract houses in the early 1950s. Most homes met the requirements of air conditioning and mass production. The emphasis was on cost efficiency with functionalism while the main surviving connection to the past was the red-tiled roofs.

Urbanization continued in full swing to the surrounding areas, as Pinellas County's population was about one and a half times that of the city until 1960, when Pinellas County increased to twice that of the city. Real estate continued to thrive with various economic ups and downs.

A change away from urban spread came in 1975 when one of the most prestigious addresses, Bayfront Tower, a new twenty-eight-story condominium and the first of such size for St. Petersburg, was built downtown. This reversal in housing trends away from the city started a beginning in downtown condominiums. However, Bayfront Tower had been involved in an earlier environmental battle over removing a banyan tree. As new developments clashed with the long-standing foliage of St. Petersburg, environmental issues had to be resolved in various ways for the continued growth of downtown.

Condominium buildings became available housing in the decaying downtown of St. Petersburg as Pinellas County's population continued to be twice the size as that of the city. The inner city saw some revitalization of people returning to live in the city as the population reached 238,647 in 1980. Yet Pinellas County population grew to 728,531that same year, three times that of the city.

More condominiums were added to the skyline of St. Petersburg. Another prominent condominium was built in the 1990s where the Soreno Hotel was built in 1924 and torn down in 1992. As the population in downtown St. Petersburg increased from 1990 to 1997 by only one thousand, the county population increased during those same years by thirty-seven thousand.

One person who has been a part of all that growth is Odette Patterson, who came to St. Petersburg in 1945 and took a job at First Federal Savings and Loan Association. She was a public relations officer and promoted real estate development in the city of St. Petersburg. She retired in 1969 from First Federal Savings and Loan, becoming a real estate agent in 1971. She became a real estate broker in 1975 and continued in the business until 1988, at the age of seventy-three.

She personified individuals who have made their fortune in St. Petersburg and later in life contributed back to the community. Odette Patterson, after becoming a widow, purchased a condominium at Bayfront Tower and established a Patterson Trust for the police and fire departments of St. Petersburg. She showed her support for the men and women in the police and fire departments of St. Petersburg.

Odette Patterson loved St. Petersburg and supported the beautiful city as it went into the twenty-first century. She witnessed the growth of the city as it grew from a population of 60,812 in 1940 to 241,413 in 1997, about four times the size. What a change in one's lifetime.

St. Petersburg, Fla. Residence Hon. Joseph C. Sibley.

Tomlinson's house had an unusual tower, called the Tomlinson Tower. There had been many postcards made of that house showing the tower.

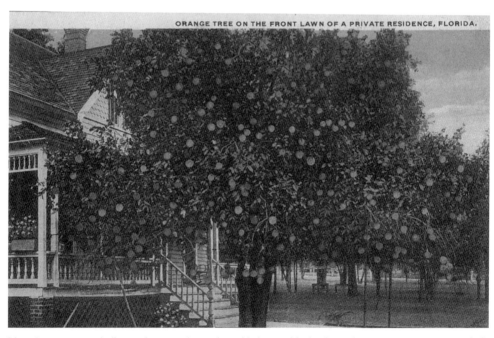

ORANGE TREE ON THE FRONT LAWN OF A PRIVATE RESIDENCE, FLORIDA.

Many homes were similar to the one pictured on this image. Notice how the orange trees surrounded the house. This wood house was typical of middle-income St. Petersburg residents while the more affluent ones had larger homes similar to the Tomlinson-Sibley home.

A postcard shows a house built in the Jungle subdivision. The home was called Jungle Manor, next to the water on Boca Ciega Bay.

A Pass-a-Grille postcard shows two houses and a flowing well on the property. This postcard was published by the St. Petersburg Post Card Association.

This first Roser Park postcard shows the banana trees in Roser Park with the Booker Creek and people standing on the road.

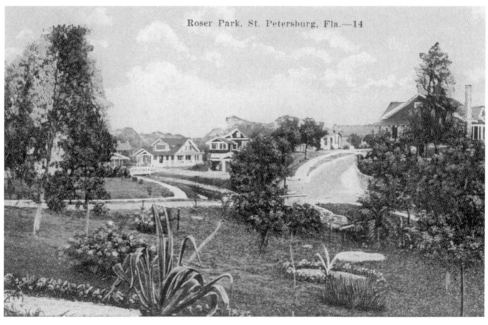

A second Roser Park postcard shows beautiful foliage on a road in Roser Park. It was published by the E.C. Kropp Co. in Milwaukee.

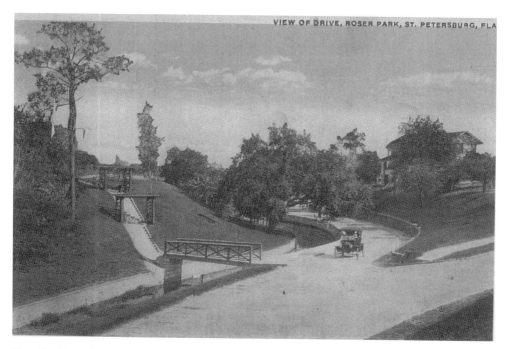

The third Roser Park postcard shows the beautiful foliage and view of a drive in the park. A bridge over part of Booker Creek is also visible. This third and the first Roser Park postcards were published by C.T. American Art, not a local company.

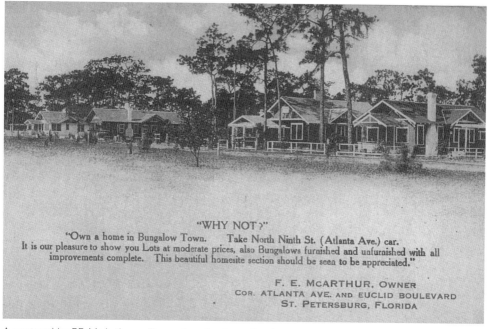

A postcard by F.E. McArthur selling and renting bungalow homes.

ST. PETERSBURG, FLORIDA ~ THE SUNSHINE CITY

St. Petersburg is known as a city of beautiful homes. It has laid out broad streets and avenues, attractive public parks and playgrounds and has all the advantages which are associated with cities many times its size.

CITY OF ST. PETERSBURG, FLORIDA. RE-INCORPORATED A.D. 1903

This 1940s home postcard was published by the Hartman Card Co. of Pinellas Park, Florida. The postcard was advertising St. Petersburg as a city with beautiful homes.

The first Arlington Terrace postcard.

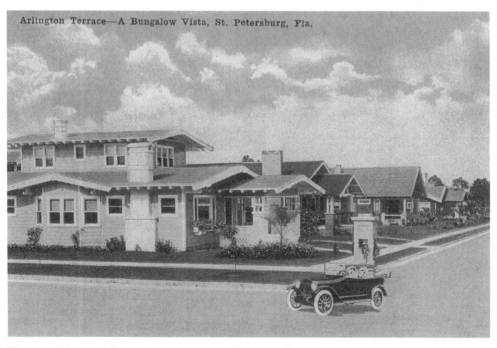

Arlington Terrace—A Bungalow Vista, St. Petersburg, Fla.

The second Arlington Terrace postcard shows a bungalow vista.

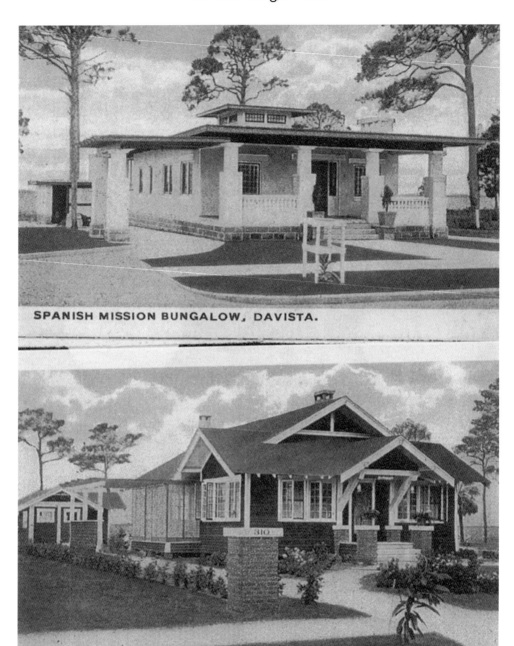

SPANISH MISSION BUNGALOW, DAVISTA.

SUNSHINE BUNGALOW, DAVISTA.

Two small postcards, both equal to about three-quarters of a regular postcard, were advertising homes in the Davista area. The Davista land was named for F.A. Davis, who died before completing the subdivision. The subdivision was acquired by Jack Taylor, who had plans for an elegant Pasadena-on-the Gulf subdivision. Jack Taylor left town owing many backers and the land became developed as the Pasadena area.

Our new home in the Sunshine City.

In tropical Roser Park overlooking Booker creek that flows between concrete banks and almost hidden by a riot of tropical flowers and shrubbery and stately royal palms and live oaks. . . Where the Blue Jay heralds the break of day and Mocking birds are more numerous than sparrows in Lexington. Come and see. Our own water system. Electrolux refrigeration and air conditioned helps to make life worth living. We do enjoy it. The latch string is always on the outside.

PINSON'S DIAL 97-853

685 NINTH AVENUE SOUTH
St. Petersburg on the Gulf of Mexico, Boca Ciega and Tampa Bays

The Pinson's real estate office overlooking Booker Creek. The back of the postcard provided "Facts about the Sunshine City of St. Petersburg, Florida."

*An Attractive Florida Home
Snell Isle, St. Petersburg*

The second 1940s home postcard shows a home on the water in Snell Isle, published by the Gulf Coast Card Co. of St. Petersburg. Notice again that the beautiful trees, foliage and red tiled roofs are displayed to emphasize the attractive homes of St. Petersburg.

Recreation, Shopping and Sports

Recreation has always been a part of St. Petersburg's history, starting when piers were created to increase the water recreation activities of tourists and residents. While the railroad pier came first, it was mostly for commercial fishing. Another pier, called the Electric Pier, was created strictly for recreational purposes and it was replaced by the Municipal Recreation Pier in 1912 after the previous Electric Pier was demolished. The Municipal Recreation Pier was replaced by the Million Dollar Recreation Municipal Pier in 1926 and that was replaced in 1973 with a pyramid-shaped Municipal Pier. While those piers were important to the city's provision of recreation, there were many other sources for recreation.

Different from most other chapters where the early history has changed, various forms of the recreation viewed in this chapter are still a part of St. Petersburg. However, the locations may have changed.

Card playing was often taken out into the sunshine, as pictured in the first two postcards. Such postcards showing people enjoying themselves outside were very common. Clothing would suggest that the events occurred in the winter.

The next two postcards show people playing checkers under a shed. The first shedded recreation view shows individuals playing checkers under a covered shed identified as being at Williams Park. There was a Sunshine Pleasure Club at Williams Park that included just about every kind of game including checkers, chess, dominoes, horseshoes and even roque (a variety of croquet played with short-handled mallets). A woman dressed in white and with a hat is present in this view. The second shedded recreation view shows checkers being played while dominos and chess were available. There were two sides of the shed enclosed as only men were seated and dressed in suits.

The next two postcards show another kind of recreation in St. Petersburg: greyhound racing at Derby Lane. Greyhound racing came to St. Petersburg in 1925 as the St. Petersburg Kennel Club opened the racing track known as Derby Lane a year after the Gandy Bridge was

completed. The original grandstand was replaced with modern concrete and steel in 1948. The first view shows the concrete grandstand and the second view shows more of the flowered infield, the judges' stand and the electronic odds board.

A clubhouse with closed circuit television at tables was added in 1966 while Derby Plaza, a five-story enclosed addition, was attached to the grandstand in 1977. This greyhound-racing track is still operating as one of the state's oldest dog racing tracks. While Derby Lane has over two hundred stockholders, the business remains a family operation.

Another type of recreation often associated with St. Petersburg, horseshoe pitching, was found only on one postcard. That one postcard was used in my previous book. However, horseshoe pitching is still considered a serious form of recreation.

Another serious recreation in St. Petersburg is lawn bowling. There was a St. Petersburg Lawn Bowling Club founded in 1915 and it has hosted several world championships over the years. The clubhouse was a wood frame building erected in 1918 and enlarged in 1923 and 1928. A Mediterranean revival style concrete block addition was constructed on the west side of the original building in 1933 and pictured on a postcard.

Notice another structure in the background, the Coliseum, is still part of St. Petersburg. It is across the street from the lawn bowling building and can be viewed through the trees.

In 1976, four rinks of the Lawn Bowling Club were demolished and the city of St. Petersburg built a second senior citizens center at Mirror Lake, called Sunshine Center. It was a replacement for the first Senior Center located on the old Million Dollar Recreation Municipal Pier. That first Senior Center can be seen on the right front side of a 1960s postcard. The low flat Senior Center building overlooking the yacht basin was identified by some hand markings on the postcard itself while the back of the card identifies the "beautiful bayfront with downtown St. Petersburg in the distance. Building to right foreground is Senior Citizens Community Center."

The second senior citizen center, called the Sunshine Center, provides services for some three thousand people living in the immediate area of downtown St. Petersburg who walked to the Sunshine Center, located around Mirror Lake. Another three thousand individuals rode buses or drove, with a total of over six thousand older folks listed as Sunshine Center members in 1977.

The Sunshine Center was again expanded in 1981-82 as nine more lawn bowling rinks were removed. Since the Lawn Bowling Club is a national historic site, permission to remove the rinks took some time. The senior citizens center continues to provide current services to the elderly of downtown St. Petersburg into the twenty-first century.

While a modern postcard of the Sunshine Center was found, it could not be used in this book because of copyright dates. It described the Sunshine Center at 330 Fifth Street and the City of St. Petersburg's Office on Aging, which operates a multi-service center with social, recreational and volunteer activities. Other community resource agencies have office hours on a rotating basis at the center. This 1990s postcard claimed that St. Petersburg had a population of 243,100 with 54 square miles and 128 miles of coastline.

Certainly some of the most prominent facilities for recreation were the piers, and there were many postcards made about them. The Million Dollar Recreation Municipal Pier

provided tourists and residents with many years of recreation and heavy traffic. Automobiles, streetcars and strolling pedestrians added to activities at the pier. Coast Guard vessels were moored alongside the Million Dollar Pier until a base was opened. A casino was added. The Million Dollar Recreation Municipal Pier became a favorite meeting site for many state tourists societies. Originally, a rooftop ballroom provided dancing. That ballroom was later roofed over because nightly humidity made the dance floor too slippery. A radio studio, WSUN, operated from the pier until it was sold in the 1960s.

The Million Dollar Pier was replaced with a new one in 1973. A picture of the current pier is on a 1980s postcard. Notice the yacht basin, downtown waterfront and the Bayfront Tower condominium on the left. The left side of the pier's entrance is where the old Senior Citizens Community Center had been and is now a parking lot. On the right side of the pier's entrance remains some of the old spa beach.

As the yacht basin developed in St. Petersburg, so did sail or small boat racing. Printed on a postcard of sailboat racing were the words, "Sailboat racing is but one of the many varied sports that may be enjoyed at St. Petersburg. Darting white sails against the bright blue of the Gulf makes a charming picture."

The St. Petersburg Yacht Club often sponsored major regattas, including an annual boat race from St. Petersburg to Havana. The St. Petersburg Yacht Club was constructed in 1916 and quickly became one of the major focal points of the downtown waterfront. Pleasure boats continued to increase in numbers as the city grew into the twentieth century.

Shuffleboard was another popular recreation in St. Petersburg. Shuffleboard courts are shown on two postcards. The St. Petersburg Shuffleboard Club was located north of Mirror Lake, established around 1916. The club was busy with many activities, including bridge and bingo.

The first shuffleboard courts were built in 1923 and membership grew to more than twelve thousand to be the largest in the world by 1950. It started with one court in 1950 and grew to 107 courts. Several national tournaments were played on the courts. Shuffleboard continues to be an active form of recreation in St. Petersburg.

Shopping has always been a popular form of recreation for residents and tourists. A downtown view of the corner of Central and Third Street around 1915 shows some of that shopping. This picture is looking east down Central Avenue towards the waterfront. The St. Petersburg Hardware Company is shown on the right, where building material and items for the home were purchased for many years. A barbershop pole is displayed out front as other stores were available down Central Avenue as the main source for shopping.

Walter P. Fuller claimed to have built Florida's first supermarket and shopping center, the Jungle Prado, in 1925. He built the shopping center first with the expectation that his surrounding subdivision of homes, the Jungle, would follow. Unfortunately, the Florida land boom hit before his plans materialized and the shopping complex was converted into an apartment hotel. Since then, the apartments have changed ownership many times and are located at 1700 Park Street North. Shopping never really developed at the Jungle Prado.

The Mecca of shopping in St. Petersburg by the 1930s was Webb City. It had everything from a floral shop, a bakery, a grocery store, a meat market, a beauty salon, a travel agency,

a hardware store, a gift shop, clothing emporiums, several coffee shops and a drug store. Doc Webb was a forerunner to the post-World II shopping centers.

Central Plaza was one of St. Petersburg's first shopping malls when it opened away from downtown on Thirty-fourth Street and Central in 1952. The acreage was formerly known as Goose Pond, a wetland. It became an innovative shopping experience with a variety of stores and plenty of parking, but its business quickly suffered when another giant shopping complex was built. That complex, called Tyrone Mall, was away from downtown. As the shopping centers grew away from the original downtown, so did the city.

There was one exception to the shopping being away from the downtown city and that was the Mass Brothers Department store. It was built across from Williams Park in 1948 as a major department store and as stated on the back of the postcard, it "was Florida's newest, most modern fashion center in the heart of the Sunshine City." It served the city until it closed in 1995, when most shopping had ceased in the downtown area.

The Mass Brothers downtown building was reopened in 1995 as the Florida International Museum. Its first exhibit drew over six hundred thousand visitors in five months. Other exhibits followed but the museum continued to struggle financially. The museum was doomed to fail and it did. The building is now expected to be razed for a new hotel in the next few years.

Shopping returned to downtown at the beginning of the year 2000 with a new $40 million complex. It opened with a screen Muvico Theater as an anchor, seven restaurants, six clothing stores, a shoe shop and other shops for unusual items, called BayWalk, reversing a trend away from downtown.

The last, but certainly not least, form of recreation in St. Petersburg was Major League Baseball. It started in 1914 as Major League Baseball arrived in the city. While there had been some amateur baseball earlier, the Major League did not begin until 1912 when the St. Louis Cardinals were offered spring training in St. Petersburg. There are three postcards that best show Major League Baseball in St. Petersburg.

Immense crowds of winter visitors and residents are shown watching the spring training games. Many local residents were big fans of baseball. One such family was the Farmer family, owners of the Farmer Concrete Works in St. Petersburg since 1905. One member, Donna Farmer Benjamin, remembered family members who were always loud and vocal about the games. When Al Lang Field was built, some of the concrete work was done by the Farmer Concrete Works and they received some of their pay in season tickets. She remembered that for the last game of the spring practice, the Farmer Concrete business was simply closed down and everyone went to the game. Her fond recollections are recorded in the St. Petersburg Museum.

The Al Lang Field was replaced by the Al Lang Stadium in 1977. In November 1996, the St. Louis Cardinals formally assigned their lease of spring training facilities in the city to another group, the Devil Rays, giving them control over Al Lang Stadium. This ended the association of the St. Louis Cardinals with St. Petersburg, having started in 1938. In February 1998, the City Council approved a name change for Al Lang Stadium to the Florida Power Park: Home of Al Lang Field, all part of a corporate sponsorship package. While the facility remains a part of the city, the name has not remained the same.

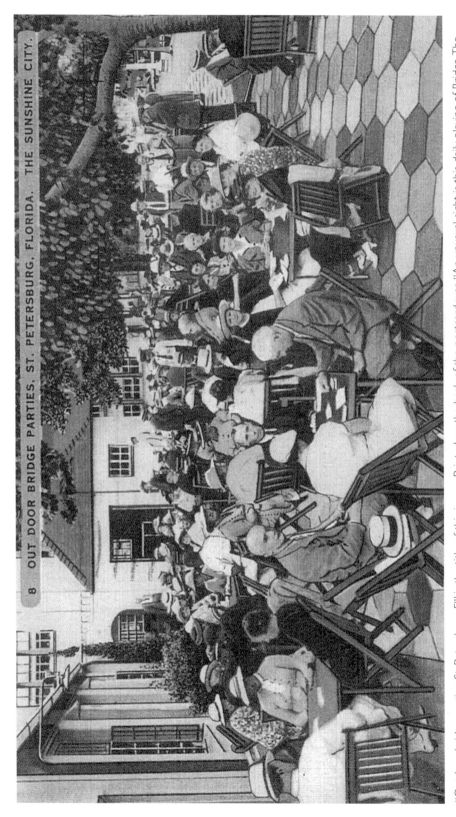

8 OUT DOOR BRIDGE PARTIES, ST. PETERSBURG, FLORIDA. THE SUNSHINE CITY.

"Outdoor bridge parties, St. Petersburg, Fl" is the title of this image. Printed on the back of the postcard was, "An unusual sight is this daily playing of Bridge. The weather conditions of the Sunshine City are such that Bridge parties are arranged and take place throughout the entire season. Close by are Mirror Lake, The Coliseum and the Shuffleboards."

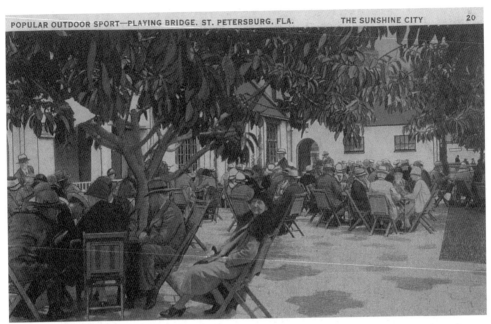

POPULAR OUTDOOR SPORT—PLAYING BRIDGE. ST. PETERSBURG, FLA. THE SUNSHINE CITY 20

A second view of playing bridge. Notice the trees and foliage, which provided some shade from the hot sun, all discussed more in chapter four. Both of the bridge-playing postcards were published by a local publisher, Hartman Card Co. in Pinellas Park.

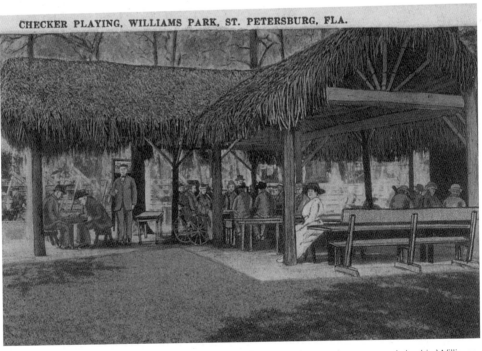

CHECKER PLAYING, WILLIAMS PARK, ST. PETERSBURG, FLA.

The first shedded recreation view shows individuals playing checkers under a covered shed in Williams Park. One woman dressed in white with a hat can be observed in this picture.

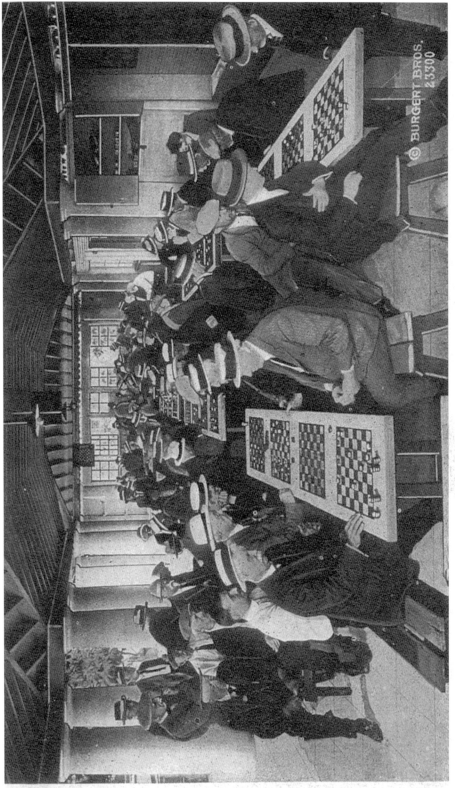

Another shedded recreation postcard shows people playing checkers, dominos and chess. The people were identified as tourists but one can only notice that they were all men, mostly dressed in suits. This postcard was published by J. Heath and Son Co. of St. Petersburg.

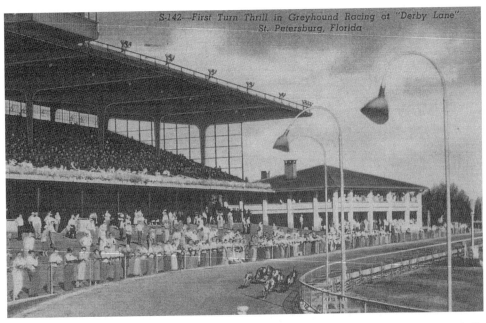

The first Derby Lane view is a 1950s postcard of the concrete grandstand showing the "first turn thrill in Greyhound racing at Derby Lane."

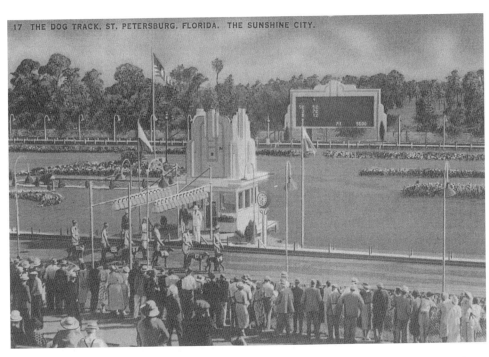

A second Derby Lane postcard shows the St. Petersburg Kennel Club's Derby Lane track with gardens dotting the infield and a new judges stand. An electronic odds board is in the background. The beautiful rock garden, reflection pool and lovely flowers made this one of the most beautiful tracks in Florida.

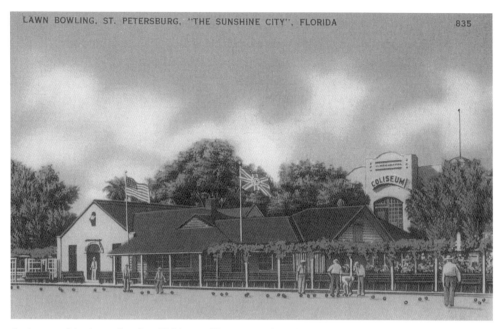

A picture of the Lawn Bowling Clubhouse. The postcard was locally produced by the Sun News Co. of St. Petersburg.

A view of the yacht basin. The first senior citizens community center is located on the right side. It has been replaced with a second senior citizens center at 330 Fifth Street. This yacht basin has been the Tampa Bay waterfront side of St. Petersburg. The entrance to the Million Dollar Municipal Recreation Pier can be seen on the far right side.

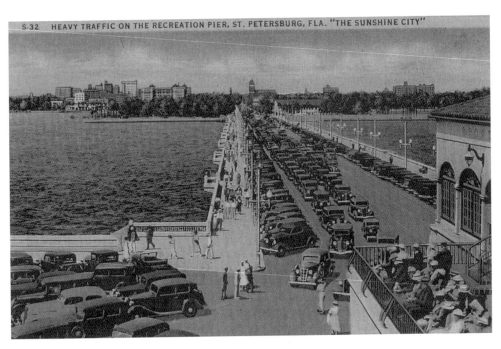

The Million Dollar Municipal Recreation Pier provided tourists and residents with many years of recreation as a 1940 postcard shows the heavy automobile and pedestrian traffic.

A picture of the current Pier on a 1980s postcard. Notice the downtown yacht basin, downtown bayfront and Bayfront Tower Condominium building on the left. Also on the left side of the pier's entrance was where the old senior citizens community center had been; it became a parking lot. On the right side of the pier's entrance remains some of the old spa beach. There have been various recent renovations to the pier but it remains the same shape as pictured.

P-105 Small Sailboat Races, St. Petersburg, Florida, "The Sunshine City"

Sail or small boat racing has become a growing recreation. The picture appears to have been taken from a corner at the Million Dollar Recreation Municipal Pier as people watched. The postcard was published by Webb's, the world's most unusual drugstore, in St. Petersburg.

Shuffleboard Courts, a Popular 2
Sport Here at St. Petersburg,
Florida, "The Sunshine City"

The first shuffleboard postcard shows people in the popular sport. Many of the men were wearing suits, ties (often with the coat off) and hats. The women are probably wearing hats to protect themselves against the sun, while some hats could have been part of the fashion.

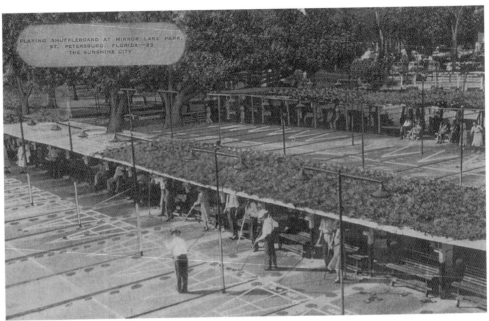

PLAYING SHUFFLEBOARD AT MIRROR LAKE PARK,
ST. PETERSBURG, FLORIDA—23
'THE SUNSHINE CITY'

The second shuffleboard postcard is a more distant view showing two rows of courts and people under cover. Notice the green benches under the cover while some men are wearing white shirts and ties. Printed on the back states, "One of Florida's most popular sports is shuffle-board. St. Petersburg has the largest shuffle-board club in the world with more than 5,000 members." This postcard was published by Rodes Distributing Co. in St. Petersburg.

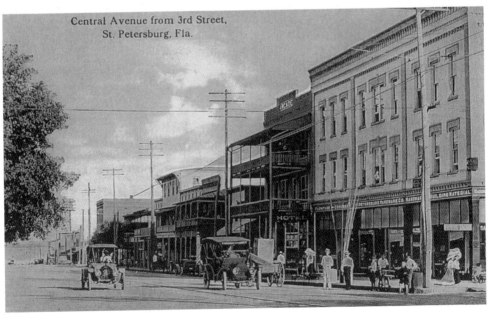

Central Avenue from 3rd Street,
St. Petersburg, Fla.

A 1915 downtown postcard of the corner of Central and Third Street, looking east toward the waterfront, shows some of the stores available for shopping.

A postcard of the Mass Department store. It was published by Sun News Co. of St. Petersburg.

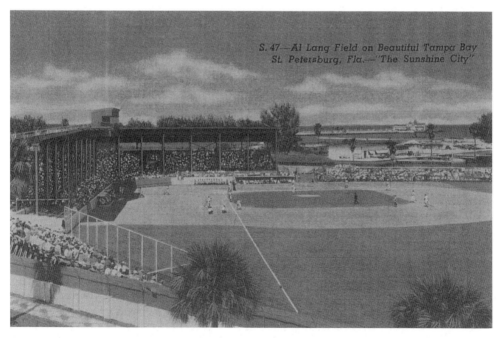

A baseball postcard shows the Al Lang Field that was named for Al Lang in 1947. The coming of the Philadelphia Phillies established Al Lang as a local hero, and in April 1916, he was elected mayor. He was reelected in 1918 and proved to be an aggressively active mayor; the Waterfront Park was named for him.

A second baseball postcard shows the Waterfront Park, completed in 1922 as the predecessor to the Al Lang ballpark. This postcard shows the Boston Braves playing as the Goodyear blimp flies over. The Goodyear blimp was a familiar sight in Pinellas County in the 1930s.

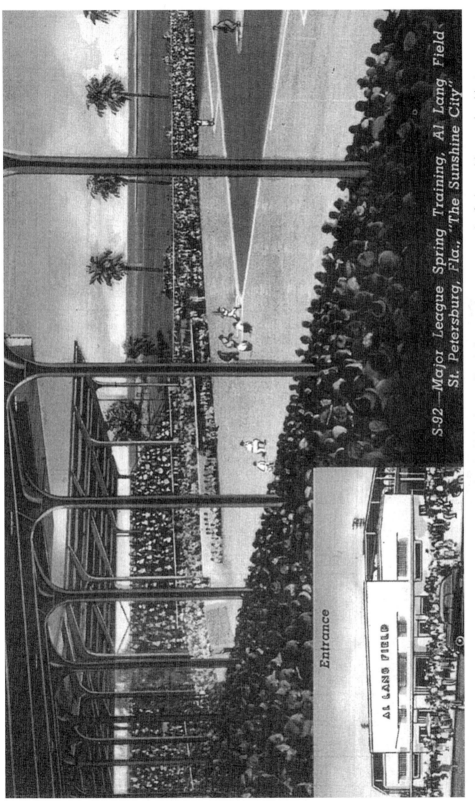

S-92—Major League Spring Training, Al Lang Field
St. Petersburg, Fla., "The Sunshine City"

Entrance

AL LANG FIELD

The third baseball postcard shows Al Lang Field as headquarters for the Major League Baseball games. Immense crowds of winter visitors and residents were on hand to watch the spring training exhibition games.

Tourist Attractions and Services

Tourism in St. Petersburg is as old the city itself. Getting to the new city took some initiative since automobiles were not present in the early days. Since railroads came to Tampa by 1884, the tourists often would cross the bay on steamer after 1899 into the new city of St. Petersburg. Some tourists tried coming by car, as one did in 1905 from Detroit, Michigan; it took him fourteen days, but most preferred the less difficult means.

The railroad had ideas of providing transportation to St. Petersburg. As early as 1889, the Orange Belt Railroad sponsored seaside tours to exotic and healthful St. Petersburg. The Orange Belt built a large bathing pavilion with a toboggan slide adjacent to its downtown fishing pier to delight visitors and local folks alike. The Orange Belt line changed its name to the Sanford and St. Petersburg Railway, and it became a part of the great Atlantic Coast Line in 1902. Despite good fishing and bright sunshine, early St. Petersburg had difficulty competing with its Atlantic coast rivals for the larger numbers of tourists.

When it became a city in 1903, the Chamber of Commerce was determined to fill the new city with free-spending tourists. It ordered up to ten thousand promotional booklets to talk about the unexcelled fishing, the healing properties of waves of salt water, the constant sunshine and the vast choice of accommodations. Postcards were created to show a city with only 675 rooms in the Detroit, the Manhattan, the Colonial, the Huntington, the Wayne, the Chautauqua, the Paxton and the Belmont hotels by 1905. Many of those postcards were published locally and have survived into the twenty-first century.

While the number of tourists coming to the city during the pre–World War I era was impressive, St. Petersburg was still too isolated. Most of the city's streets remained unpaved, gasoline was scarce and county roads were virtually nonexistent prior to the issuance of county road bonds in 1912. In 1915, the Florida legislature created the State Road Department to add

more roads and began building an extensive highway program while the Dixie Highway and Lincoln Highways had been completed to Florida.

The Ford Tin Lizzie was produced in 1916 and tourists slowly increased each year thereafter. Prior to 1920, 80 percent of the tourists arrived by train and 20 percent came by boat and auto. After 1920, 80 percent arrived by auto. While Pinellas County had worked hard to improve its roads for the tourist trade, the economic benefits would not be felt until after the 1920s.

A new breed of vacationer came by car in the early 1920s. They preferred to stay in campgrounds rather than in hotels, requiring a different type of accommodation than the usual hotels. The mayor, Noel Mitchell, established a novel creation of a municipal campground designed for what were then called the tin can tourists. The city owned a lot at the corner of Eighteenth Street and Second Avenue South and it became the first squatters' campsite in the city. It was only two blocks from the trolley on Central Avenue. It provided free campsites with running water, toilets, showers and electricity as the practical tourist brought along most of their food in tin cans. There were small metal ovens attached to the car engine where food could be heated. Visitors had everything they needed. Mayor Noel Mitchell used the campground to draw the tin can tourists to St. Petersburg and it worked. A picture of tin city is available on a postcard.

Private campsites eventually became available and some rented by the season for fifty dollars. A National Tin Can Tourist organization was formed in 1922 and the first convention was held in Tampa with thirty thousand people in attendance.

As the tourists continued to come by automobile, accommodations grew to meet their wishes. The next six postcards show campsites of the 1920s through '40s in St. Petersburg. The first such campsite, Lowe's, is on three different postcards with the location of the camp and the cost given. Conveniences listed included electricity and water, dance hall and city bus line.

An article written on July 29, 1991, by Betty Jean Miller of the *St. Petersburg Times* titled, "Pinellas Past and Present" talked about the Lowe's St. Petersburg Campgrounds. Charlie Lowe was quoted as saying his grandfather, Clowney Edgar Lowe, bought the land after moving to St. Petersburg in 1908. The 250-acre tract extended from Central Avenue to Fifty-third Avenue North and abutted Twenty-eighth Street. Lowe sold the land during the real estate boom in the 1920s for $500,000 to Thomas and William Ogles, who started a campground for the "tin can" tourists.

The Ogles brothers went broke in the real estate bust of the 1920s and Lowe found himself owner of the property again. He and his son, C.O. Lowe, added cottages and the property contained 140 cottages by 1965. Some of the acreage was sold and other parts were leased so that Lowe Park had been reduced to about forty acres in 1976. It has become principally a mobile home park with 357 lots and has a winter population of 450 to 500 people. Only 11 of the original cabins remained when the article was written in 1991.

Another campsite postcard shows a different tourist park, located two miles south from Central Avenue on Fourth Street, called White City. It had 75 cabins and 220 trailer lots with dances, shuffleboards and horseshoe courts. It was located in an eight-acre park with plenty of shrubs, flowers and palms for shade. It was near a business section, fishing, bathing, boating

and even school. Printing on the back stated, "White City looks different as many changes have been made for your comfort and pleasure. New post cards are being made to tell the story. Watch for yours and compare." The tourist parks competed for business by postcards.

The next two campsite postcards will show the All States Court and Tourist Camp with an address near to the White City Campsite. This camp was south on Fourth Street to the end and turn right two blocks to the entrance, appearing to be near the previous White City Tourist Camp. However, this All States Court claimed to have forty-eight bungalows as furnished homes with private bath, garages, light, water, gas ranges and gas heater. It had seventy-six other large restricted campsites with modern conveniences with rates by the day, week or month.

A second postcard of All States Court and Tourists Paradise identified the location as being at Big Bayou, St. Petersburg, Florida. The advertisement was consistent with the other All States postcard, stating that the community was a highly restricted facility of forty-eight furnished apartment bungalows, modern in every respect, and seventy perfect campsites for high-class people. It claimed to always have the cheapest rates.

A different type of tourist accommodation was identified on St. Petersburg postcards as Doll Houses, located at 1325 Fourth Street South. They had kitchenettes, coil spring, inner spring mattresses and complete baths. The postcard was printed in the 1940s. There were many such places available throughout the city but the Doll Houses showed a mixture of campsites and early motels.

These same Doll Houses were later called Doll House Manor Apartments at 1325 Fourth Street South and advertised in a brochure in the 1950s. They became one or two bedroom efficiencies with central air conditioning and heat. They had colored GE kitchen appliances, wall-to-wall carpeting, television in each apartment, maid service and a restaurant on the premises. They rented by the week, month, season, or year, typical of many in the city. Instead of advertising on postcards as shown previously, the Doll House Manor Apartments advertised with a brochure describing different floor plans and views. For some, advertising on postcards had lost its appeal while brochures were growing in popularity and competition was still strong.

When tourism grew into a major industry in St. Petersburg, the accommodations changed to meet the demands. There were attractions that were part of the early history of St. Petersburg, such as the Fountain of Youth, a sulfuric artesian well identified with having restorative powers, founded by Edwin H. Tomlinson in 1900. Since it was near the waterfront, Tomlinson built a long wharf with a cottage on the end.

A physician, Dr. Jesse Conrad, connected with a health sanitarium in Magnetic Springs, Ohio, gave the artesian well and pier the name of "Fountain of Youth." Dr. Conrad purchased the well on the pier while vacationing in St. Petersburg in 1908 for the sum of $2,800.

Dr. Conrad claimed that St. Petersburg would become a famous health resort following Dr. W.C. Van Bibber's earlier predictions at the American Medical Association's Annual Convention that St. Petersburg was becoming a health city. Dr. Van Bibber had already built a health resort hotel on Central Avenue called the Clareden.

Customers who came for the mineral water baths also drank the water. A later chemical analysis determined the Fountain of Youth to contain the highest lithium content in Florida.

The lithium level in water made people claim that they "felt younger"; lithium is now used for antidepressant medication.

In 1911, the City of St. Petersburg purchased the Fountain of Youth property for $5,000. The cottage was torn down and a fountain was made for the well to provide the mineral water for drinking. In October 1921, a hurricane destroyed the pier's access to the fountain. The well was piped to a fountain at Third Avenue South.

The Fountain of Youth was moved a few yards in 1946 when Al Lang Field was expanded. A 1950s postcard shows the view of the Fountain of Youth at that time. The Fountain of Youth was again moved in 1966 to its present site close to First Street at Fourth Avenue South.

Other tourist attractions had limited St. Petersburg histories, such as the Florida Wild Animal Ranch. It followed several roving animal shows that grew into a locally based attraction. The next three postcards will show animals at the Florida Wild Animal Ranch at St. Petersburg around the 1940s.

Another farm, showing peacocks, was available for the tourists to visit while in St. Petersburg. The history books have no record of this peacock farm, indicating that it was a private venture that did not last long, but it is recorded on postcards.

An ostrich farm was a different tourist attraction because it was well documented in the early history of St. Petersburg. In 1908, Jerry and Ester Wells came to St. Petersburg, bringing their French ostriches. The Wells Traveling Exhibition worked state fairs and other exhibitions to race or show their rare birds. They leased twenty acres from the city of St. Petersburg on Eighteenth Avenue South and Fortieth Street. The trolley line from St. Petersburg to Gulfport ran past the attraction. The tall birds were penned in with a nine-foot wooden fence around the entire tract.

The Wells family built a bungalow with a ticket and gift shop where they sold postcards, ostrich eggs painted with Florida scenes and ostrich plumes. The women of this time coveted the beautiful plumes to wear on their hats.

A racetrack was built to allow young men to race the ostriches bareback. Jerry Wells would race them by driving a fitted surrey cart; he was always a star driving the ostrich cart in the St. Petersburg's Annual Washington Day Parade down Central Avenue. A merchandise booth where items could be purchased was always present when the ostriches were displayed.

The ostrich farm came to a halt one day in 1914 when a fire burned the farm down, creating such heat that all ostriches and animals were killed. The family escaped unharmed but the farm was a total loss and ruined the Wells financially. They did build a new home on the property and continued to live there for many years, but the ostrich farm was gone.

Since there were many farms for tourists to visit in St. Petersburg, it would be obvious to have an alligator farm. A postcard shows the St. Petersburg Alligator Farm and Zoo. The Alligator Farm and Zoo was located at 3601 Sixth Street South and was no longer listed in the city directory after 1944. The owners, Anna and Andrew Baker, had obtained many of their alligators from Big Bayou, south of St. Petersburg. One could travel down Sixth Street South to Thirty-sixth Avenue or pay twenty-five cents to ride in a fringed surrey to visit the Alligator

Farm. A date when the Alligator Farm and Zoo opened or closed is a mystery but its existence is recorded on old postcards.

As tourists continued to pour into St. Petersburg, they developed tourist societies made up of people from various localities in the United States. The services to the tourists aided in making St. Petersburg one of the most famous resort cities of the world. The societies provided tourists an ideal means for them to mingle with others from their state. Entertainment was available at regular intervals throughout the city. By the 1950s, a building on Fourth Street and Third Avenue South was built for the tourists, showing how important the tourist industry was to the city of St. Petersburg.

Services to tourists included a publication called *Tourist News*, started in 1920 with Karl Grismer as managing editor. The magazine continued until 1930 with Jack D. Dadswell as owner and president. A March 29, 1930 edition sold for ten cents and had pictures of St. Petersburg's Annual Festival of States. It did a tribute to Moses and his band with listings of movies and musical events, all appealing to the visitors of the city.

Other services to the tourists included city maps made available to them throughout the years. In the 1960s, a Suncoast Vacation Map was available on a postcard. It shows St. Petersburg and the Gulf beaches in relationship to Clearwater and Tampa. It shows the Sunshine Skyway Bridge going to Palmetto, Bradenton and Sarasota, giving a good overall view of the area at the time.

In comparing this map to one of 1969 at the St. Petersburg Museum, the highway labeled as 4 in the postcard was actually highway 75 and is now called the Howard Franklin Bridge, opening in 1960. It became a twin span in 1993 and became a part of Interstate 275 later.

The map shows St. Petersburg in relationship to Tampa, Clearwater and the Gulf beaches. It shows the Sunshine Skyway connecting to southern cities of Palmetto, Bradenton and Sarasota as the whole has developed.

At the time of this 1960s postcard, the Bayfront Center was the biggest civic project undertaken at that time. It was expected to erect an 8,000-seat arena with a 2,200-seat theater under one roof. A nearby convention center was expected to accommodate basketball games, ice-skating, political rallies, exhibitions and fairs into a multi-million dollar complex. The Bayfront Center was completed in 1965 but the convention center never materialized. At the time of this postcard, there were the big expectations with the Bayfront Center.

There have been other expectations by the planners and citizens that never materialized or failed. But the city has continued to face such failures and resurface with newer plans that have materialized. That perseverance, too, is a part of the history of St. Petersburg.

A picture of tin city.

WEST OF HAINES ROAD, 5380 28TH STREET, NORTH
OVER 100 COTTAGES — $12.00 AND UP PER MONTH
ONE BLOCK FROM CITY BUS LINE — 3½ MILES FROM
MAIN POST OFFICE
LOWE'S ST. PETERSBURG CAMP GROUNDS
C. O. LOWE, MANAGER, TEL. 44515, ST. PETERSBURG
FLORIDA

The first campsite postcard shows Lowe's Camp, west of Haines road, 5380 Twenty-eighth Street North, with over one hundred cottages that rented for twelve dollars and up per month.

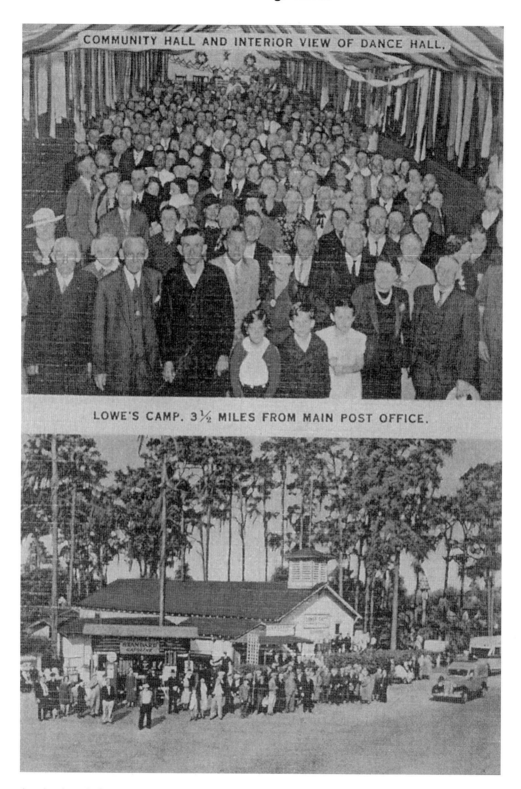

COMMUNITY HALL AND INTERIOR VIEW OF DANCE HALL.

LOWE'S CAMP. 3½ MILES FROM MAIN POST OFFICE.

Another Lowe's Camp postcard shows the community hall and dance hall available there.

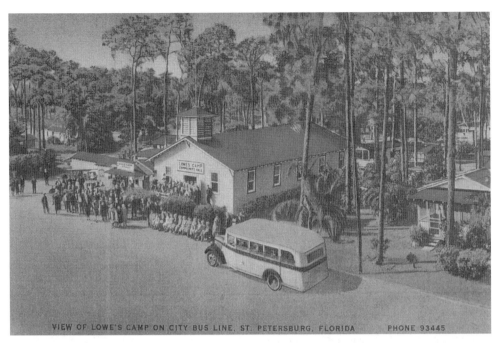

VIEW OF LOWE'S CAMP ON CITY BUS LINE, ST. PETERSBURG, FLORIDA PHONE 93445

A third Lowe's Camp postcard shows the camp on the city bus line with more advertising on the back. The printed back claimed to have one hundred cottages with steam or wood stoves in all cottages. They had flush toilets with hot and cold showers. There was a grocery store, restaurant on the grounds, shuffleboard with square and round dancing at the camp. It was proclaimed to be a new way to stay in St. Petersburg.

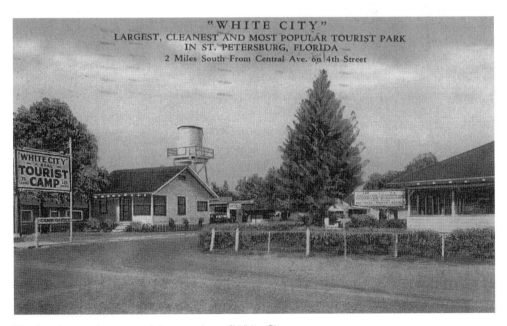

The fourth campsite postcard shows a view of White City.

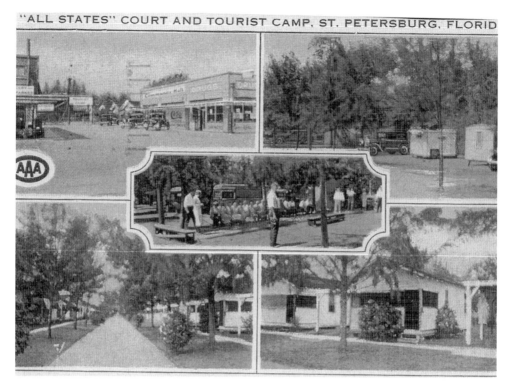

First picture of the All States Court and Tourist Camp.

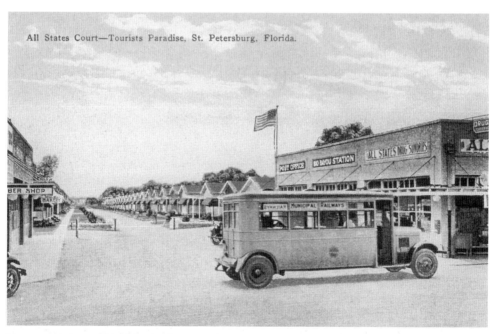

The second view of the All States Court and Tourist Camp. Both postcards had extensive printing on the back advertising the facility. Interestingly, they were not locally published.

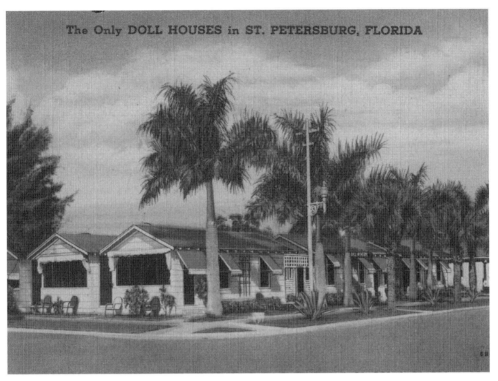

An advertisement for the Doll Houses, a different type of tourist facility.

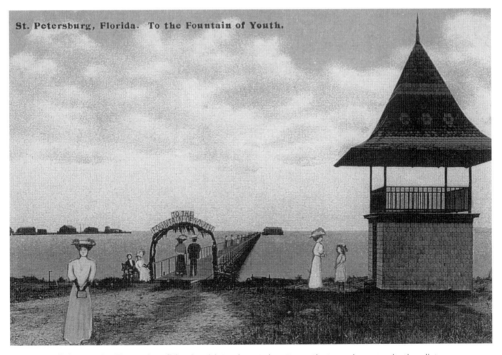

A postcard shows the Fountain of Youth with a pier and cottage that can be seen in the distance.

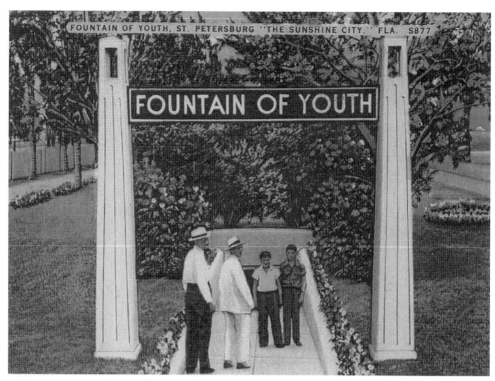

A 1950s postcard shows the view of the Fountain of Youth at that time.

This first Florida Wild Animal Ranch postcard refers to St. Petersburg's history of the green benches as cute monkeys were dressed and seated on green benches.

S-102—Mother and Baby Monkey
at Florida Wild Animal Ranch,
St. Petersburg, Fla.

A second Florida Wild Animal Ranch postcard shows a mother and baby monkey.

A third Florida Wild Animal Ranch postcard shows Peccary the wild boar.

A postcard of the Peacock Farm was sent in 1948.

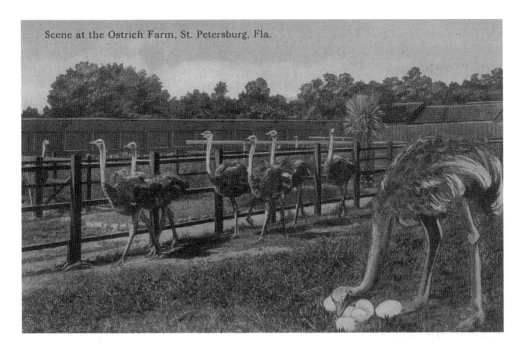

Scene at the Ostrich Farm, St. Petersburg, Fla.

The Ostrich Farm of St. Petersburg is pictured.

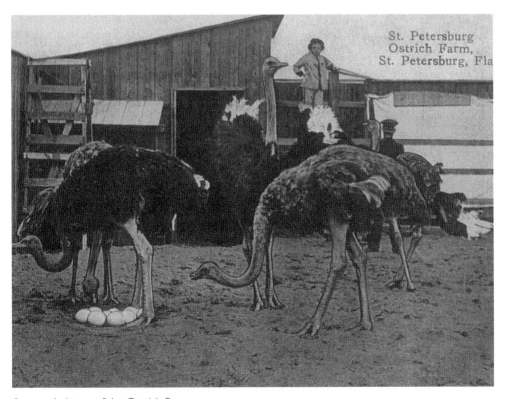

St. Petersburg
Ostrich Farm,
St. Petersburg, Fla

A second picture of the Ostrich Farm.

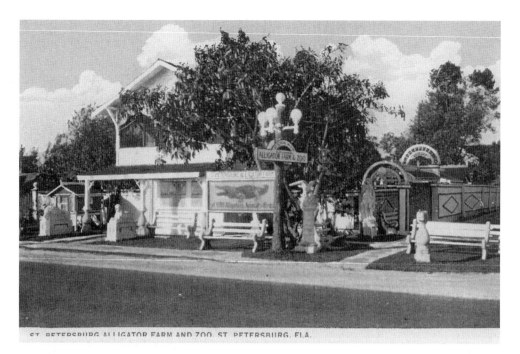

ST. PETERSBURG ALLIGATOR FARM AND ZOO, ST. PETERSBURG, FLA.

The St. Petersburg Alligator Farm and Zoo postcard claimed to be the most complete exhibit of Florida's wildlife in the state and to have been visited by people from all parts of the world.

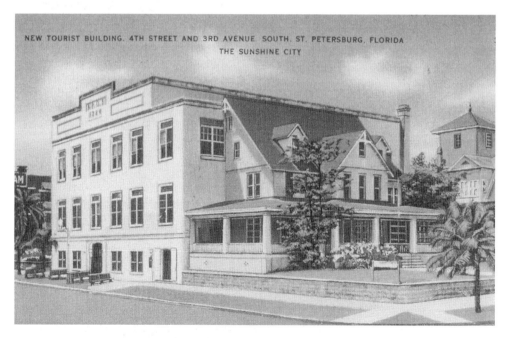

NEW TOURIST BUILDING, 4TH STREET AND 3RD AVENUE SOUTH, ST. PETERSBURG, FLORIDA
THE SUNSHINE CITY

A picture of the New Tourist Building. This building had been identified on another postcard as a "splendid Tourist Center where visitors register, meet friends and a free writing room with information of the city."

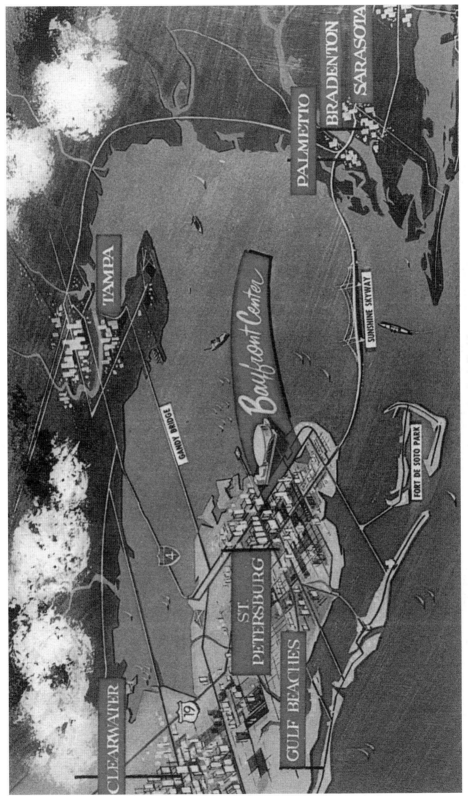

The Suncoast Vacation Map postcard published by the Sun News Company, Pinellas Park, Florida.

Trains, Trolleys
and Transportation

It is certainly apropos to start this chapter with the trains since they were the first transportation into St. Petersburg. Peter A. Demens, as president of the Orange Belt Railroad, negotiated with General J.C. Williams, the founder of St. Petersburg, to build a railroad to St. Petersburg. After many difficulties at the start, the railroad was completed to the edge of the Williams property on April 30, 1888. The first train came into St. Petersburg from the eastern end of the line on June 8 that same year, connecting St. Petersburg with the Jacksonville, Tampa and Key West Railroad. The tracks were laid down First Street South in December and a fishing pier into the water was completed about a year later. The fishing pier was over three thousand feet long into the ten-foot deep water, permitting ocean vessels to dock.

The Orange Belt Railroad continued to go into debt and it was absorbed by another line, the Sanford & St. Petersburg Railway. Problems persisted until the Atlantic Coast Line (ACL) took over the railroad in 1902.

On December 22, 1906, the Atlantic Coast Line announced that it had purchased new equipment and better service would be provided in the future. The first Pullman, called Salome, from New York City to St. Petersburg, arrived on November 16, 1909. The first special train for tourists reached St. Petersburg on January 9, 1913, bringing two hundred winter visitors from Cleveland, Akron, Mansfield, Steubenville, Miles and other points in Indiana. It was a big event for St. Petersburg.

The Tampa & Gulf Coast railroad connected St. Petersburg with Tampa on September 22, 1914. Double daily passenger service connected St. Petersburg with Tampa directly from Jacksonville. The excellent service given by the railroads became an important factor in making St. Petersburg one of the greatest resort cities in the world.

A new brick depot was opened March 26, 1915. This passenger depot was built on the site of the original Orange Belt depot at First Avenue South between Second and Third Street.

A picture of that ACL passenger depot is on an old postcard. This postcard was hand-stamped by Lyn Friedt, indicating that it came from his personal collection.

During World War II, the train service to St. Petersburg was curtailed, as it was in other sections of the country. The following postcard shows the train service on First Avenue South in St. Petersburg during World War II. Notice the old ACL passenger depot and airplane in the background. Since the airplane is flying very low, it was probably inserted into the picture by the publisher. The cars and people reflect the times on First Street South. This postcard is very highly prized by collectors.

The back of the World War II train postcard has an interesting handwritten message by the sender, Private T. Pettee (not sure of spelling since it was difficult to read), with a return address of 622 T.G. 511 Squadron, Ponce de Leon Hotel, St. Petersburg, Florida. He addressed the postcard as "Dear Folks," written on May 11, 1943. "This is quite an experience I am having and am lucky in being sent down here. I do have a little time to look around and have seen a lot of new things. My basic training lasts only several weeks longer then I expect to go for technical training. I miss the spring that is at about its best up there. Now as ever, Thornton." That postcard is a real reminder of the war efforts in St. Petersburg from a personal viewpoint.

The preprinted backside of the postcard praised the "Atlantic Coast Line's crack Florida Special which offers new equipment and the fastest time from New York to St. Petersburg in railroad history. Both the Atlantic Coast Line and Seaboard Air Line have terminals in St. Petersburg connecting this city with all principal terminals of the North and East."

By the 1950s, the railroad tracks along First Avenue South had become an unsightly obstruction. As the downtown grew, the First Avenue South site of the ACL depot proved to be too disruptive to both pedestrians and auto traffic. The city started pressuring the railroad to remove not only the tracks but also to relocate their depot. In 1963 the railroad gave in and the last passenger train ceremoniously crept out of the downtown into a more suitable location. A depot was hastily put up on Thirty-first Street North and Thirty-sixth Avenue as the downtown was cleared of the railroad and its tracks.

It was an ironic dilemma faced by many cities that seventy years earlier St. Petersburg had begged the railroads to bring their trains into the downtown city. As the railroads brought life to the city, railroads became an interference to the downtown as the city grew. St. Petersburg continued to multiply in size into the twentieth century without the downtown train.

Another early source of transportation for the city of St. Petersburg was the trolley. The first trolley cars cruised up and down Central Avenue to Ninth Street starting in 1905. Then later, the trolley turned south on Ninth to Booker Creek. Booker's Creek Bridge was next to the entrance to Roser Park, developed in 1911. By 1921, nearly one hundred homes had been built in Roser Park.

The trolley line was extended to Disston City, now called Gulfport, and the more southern tip of the city. In 1911, a line was run to the Bayboro area and to the Coffee Pot Bayou to accommodate the North Shore development. While the trolley never made money, the investors in Disston City, Bayboro and North Shore pleaded for trolley service and willingly

bore the expense of additional lines as those developments grew. The ones heading west on Central passed through orange groves toward the Jungle area.

As the Million Dollar Pier became a source of recreation for thousands of residents and tourists in the 1920s, the trolley provided some of that transportation. The trolley went inside the Million Dollar Pier building's first floor, where the conductor flipped the seats to face in the opposite direction and drove off. A picture of the trolley inside the pier's building can be seen on a postcard.

Trolleys were very important to the early business and home development in St. Petersburg. As the demand for trolleys increased, a transfer station was built in the middle of Sixth Street North between Central and First Avenue. Two wheel-less trolleys were permanently anchored to the roadbed where visitors could change lines. The trolleys were retired in favor of buses in 1936 and the transfer station was removed in 1944. The last trolley ran in 1949.

Another early source of transportation into St. Petersburg was the ships or steamers. An Independent Line with two steamers had been operating since 1899. F.A. Davis purchased a steamer around 1905 called the *Favorite*, on which five hundred passengers made periodic runs to Tampa. It was much too large for the St. Petersburg to Tampa run and was replaced by a smaller and more profitable vessel. For a time, watching the *Favorite* pull into the Electric Pier was a popular activity for tourists and locals. Other maverick steamer lines continued to compete for dominant roles in freight and passenger commerce, which they felt sure was to come to St. Petersburg via the water. It is important to recognize the value of the steamers for transporting people during a specific time in the history of St. Petersburg.

The port of St. Petersburg, located at Bayboro Harbor, was opened in 1925. It was expected to become a major shipping port in the area. A new channel 19 feet deep and 250 feet wide was dredged from the deep water of Tampa Bay to create Bayboro Harbor and the port. Dredging of the harbor for the port provided other landfill for the establishment of the Albert Whitted Airport, a Coast Guard base and a Maritime Service Training Center.

As early as 1927, four patrol boats at the Coast Guard Base Number 21 were east of the port. They were part of the war against rumrunners and alien smugglers as five more Coast Guard patrol boats were added. Four of the patrol boats remained after the base was abandoned in 1933. The Coast Guard Base was reopened in 1939 as war in Europe developed.

The port of St. Petersburg had nearly two decades of dry-dock after World War II. In 1977, there were hopes of the port of St. Petersburg becoming a cruise port. Hopes of a cruise line with regular voyages to exotic ports were reported in the *St. Petersburg Times* on November 14, 1977. The problem centered around water depths in the port of St. Petersburg, which ranged from fifteen to twenty-one feet, whereas most major cruise ships drew twenty-four to twenty-eight feet. The port of Miami was thirty-seven feet deep and the port of Tampa was thirty-four feet. There were still attempts to gain a cruise line into the port of St. Petersburg.

In 1987, the Scandinavian Star offered cruises into the Gulf and to Mexico out of the port of St. Petersburg. This cruise line continued until 1991, when it moved to the port of

Miami. In 1993, a Ukrainian cruise ship called the *Gruziya* began to sail out of the port of St. Petersburg, but it did not stay long. The port of St. Petersburg has continued to have difficulty maintaining a major cruise line for any length of time.

A later source of transportation was aviation. St. Petersburg has an illustrious history starting on January 1, 1914, when Tony Jannus, a twenty-four year old pilot from Washington, D.C., flew his Benoist airboat across Tampa Bay. This hailed the birth of commercial aviation as a scheduled flight between Tampa Bay and St. Petersburg. The event caused a sensation in the weeks that followed with two roundtrips a day, transporting 1,200 passengers and thousands of pounds of freight without a major accident. By the first week in May the airboat line was suspended. The city had hoped to develop early aviation in the area and such hopes receded at the time.

St. Petersburg's first airport was built by Walter Fuller in 1926. It was designed as an amenity for tourist-orientated projects that the owner was involved with and to show his surrounding subdivision, the Jungle. During World War II, this private airport, called the Piper-Fuller Airport, was activated for trainer planes. While there was interest in developing the airport after the war, the proposal was defeated by the Jungle Property Owners Association to develop into more housing.

It was in October 1928 that the city council authorized the construction of an airfield to be named in honor of Albert Whitted, a celebrated local flyer who had been killed in a plane crash near Pensacola in 1923. The hangar was completed by December of 1928.

Shortly after the airport's opening, the dirigible craze was in full swing and the city leaders convinced the Goodyear Tire and Rubber Company to station one of its blimps at the new field. A hangar was completed by September 1929, hoping that the blimp would become a popular tourist attraction and symbol of the city's economic recovery.

However, no one foresaw the stock market crash in October of 1929 and as the blimp hangar went up, the value of stocks went down. The lofty dream of the Sunshine City came crashing down to earth as the tourists left and city residents were left to pay for the blimp hanger. A picture of the blimp and hangar at the Albert Whitted Airport is on a postcard.

In 1934, a four-passenger Ryan Monoplane left Albert Whitted Airport for Daytona Beach on the first regularly scheduled flight of a new, locally based airline called the National Airlines. Mr. Ted Baker and Peter Hubert were two of the early people associated with that airline. Peter Hubert, a jack-of-all-trades, had driven from Chicago to St. Petersburg in an old Model A Ford to service the Ryan Monoplane. Hubert, Baker and others equally shared the ground chores as National Airlines grew into a fleet of four planes. By the fall of 1939, National Airlines abandoned its St. Petersburg headquarters and moved to a smaller house on the Jacksonville Municipal Airport.

During World War II, Albert Whitted Airport was lengthened and a new north and south runway was constructed. The airfield was used to train Naval Aviation Cadets.

Pete Hubert joined the Air Force as the nation went to war. Peter Hubert returned after the war and had a repair shop at the Albert Whitted Airport. He met another pilot, Ruth Clifford, who had been a WASP during the war, and they married and lived in St. Petersburg.

Albert Whitted Airport was in a somewhat dormant state after the war. The tower was commissioned on June 1, 1955. An airport manager was appointed and the job of rehabilitating the airport in an economic manner was to begin. By 1965, action was initiated by the FAA to renovate the old control tower structure and install the necessary radio equipment with personnel for Air Traffic Control.

A postcard of the late 1960s shows an aerial view of the Albert Whitted Airport, the St. Petersburg port and location of the former Marine Service Training base, now part of the University of South Florida. The Coast Guard Base is located outside of the picture on the right of the Whitted Airport. It shows the downtown waterfront with the Bayfront Center, the Al Lang Field and two piers into the water. One was the old ACL Pier, renovated into what is now called Demons Landing and the second was the location of the old Million Dollar Pier in the process of being renovated. The Million Dollar Pier was demolished in 1967 and replaced in 1973 with an inverted municipal pier.

The Coast Guard used the Albert Whitted Airport for their airplanes and rescue missions until 1976, when they outgrew the site. While the Coast Guard Base continues to be located near the Whitted Airport in St. Petersburg, their airplanes were moved to the St. Petersburg-Clearwater International Airport.

The tower was closed after the controller's strike in 1981 as consideration was given to closing the facility permanently. The tower was reopened on January 16, 1984, and was retained for airport use. The city agreed to explore improvements to the airport. In 2001, there were attempts to close the airport but the citizens of St. Petersburg voted against closing it. Plans are being made to improve the airport, as smaller planes are being needed more. While the Albert Whitted Airport is changing to meet modern needs, another organization is preserving the history of that airport.

While automobiles were reported in St. Petersburg as early as 1905, until the roads were improved, transportation by automobile was limited to the growing area of St. Petersburg. As a source of major distance, the automobiles were limited. Yet since 1902, George S. Gandy dreamed of a shortcut route between Tampa and St. Petersburg, which at that time was forty-three miles of difficult road. By 1915, Gandy had hired surveyors and determined the rights of way, but delays set in.

World War I broke out and construction material was scarce. After the war, the cost of materials was prohibitive. He pursued and starting in 1922, the construction was underway. The cost was $3 million and took two years to finish over 3 ¼ miles of causeway between Tampa and St. Petersburg.

That bridge inaugurated a new era. It dissipated the problem that plagued St. Petersburg since its founding, its lack of accessibility. A tollbooth at the entrance of the Gandy Bridge collected seventy-five cents per car and ten cents per passenger. There is a postcard of the tollbooth.

E.G. Barnhill did a hand painted photo of the Gandy Bridge in his inserts. Handwriting on that photo with dates of "Jan. 12, 1927 and Jan. 15, 1927 in Cadillac" shows that the writer was proud to be on the bridge.

The Gandy Bridge didn't hamper the ferry business to the south but it did eliminate the steamer traffic across Tampa Bay to St. Petersburg's waterfront. The last steamer from Tampa sailed off in 1924.

Another ferry, the Bee Line, opened in 1926 starting from the southern tip of Pinellas County into Manatee County, a forty-five minute ride. It made eight roundtrips a day. It was nothing fancy but the tugboat-like vessels reduced the mileage south of St. Petersburg by forty-three miles compared to the overland route into the next counties. A picture of the *Manatee*, a Bee Line Ferry, is on a postcard.

Building a bridge or tunnel from the southern part of St. Petersburg to the next county, Manatee, had been discussed for decades. A port authority was formed to do the job in 1939 but plans were interrupted by World War II.

As the population of St. Petersburg hit 96,738 in 1950, the city was spreading out all over the southern end of the peninsula. A link with St. Petersburg and the southern counties of Florida was a dream that was soon realized. The Sunshine Skyway Bridge took fifteen years to complete and it opened on September 1954.

The bridge reduced the overland trip from St. Petersburg to Manatee County by forty miles. While the Bee Line Ferry provided a shorter more direct route, it was closed when the Sunshine Skyway was opened. Like all the previous steamers, this ferry was also gone.

A view of the Skyway Bridge as ships go under it and helicopters fly over it is on a postcard. The use of the Sunshine Skyway Bridge increased from 1,025,506 cars in 1955 to 3,336,254 cars in 1970, revealing the need for a four-lane bridge. A second span of the bridge was opened in 1971. One-way traffic can be seen in a postcard, as it was part of two bridges going in different directions, resolving the need for a four-lane bridge.

On May 9, 1980, the freighter *Summit Venture* crashed into a support column of the southbound span of the Sunshine Skyway Bridge. Portions of the bridge collapsed as thirty-five people died. Soon work started to rebuild the bridge with safety pylons that would protect the bridge from other ship disasters. In 1987 after five years of construction, the bridge was rebuilt and spanned 4.14 miles.

Two parts of the remaining old bridge were converted into fishing piers. An article in the February 23, 1990 edition of the *St. Petersburg Times* titled, "Old Skyway attracts steady stream of anglers," described the many fish species available around the old bridge all year long. Although the old Skyway Bridge came from a disaster, the remains have became a favorite source of fishing in St. Petersburg. This present source of fishing is a reflection back to the first pier in St. Petersburg being used for fishing and the continued importance that fishing has had for St. Petersburg.

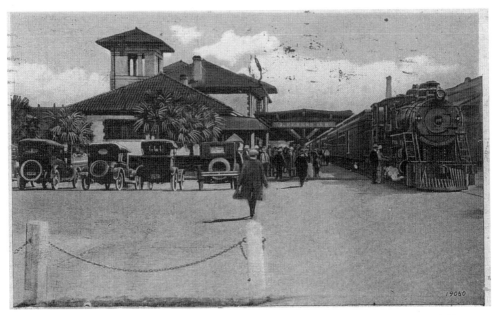

A postcard of the ACL passenger depot. This postcard was mailed on August 9, 1929, to address 647 Thirteenth Avenue South, St. Petersburg. It stated, "Just came in this morning going right out again. Will give you a ride Monday when I get in. Charlie." It was published by the J. Health & Son Co. of St. Petersburg.

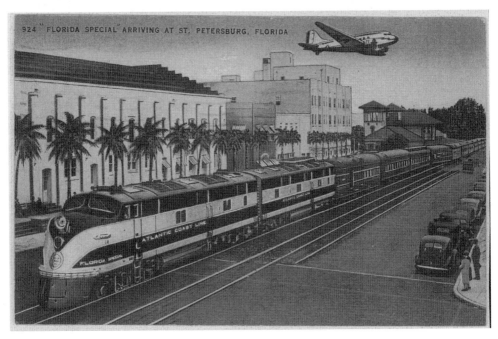

A World War II postcard of train service into downtown St. Petersburg.

A picture of a trolley on a 1920 postcard crossing Booker's Creek Bridge.

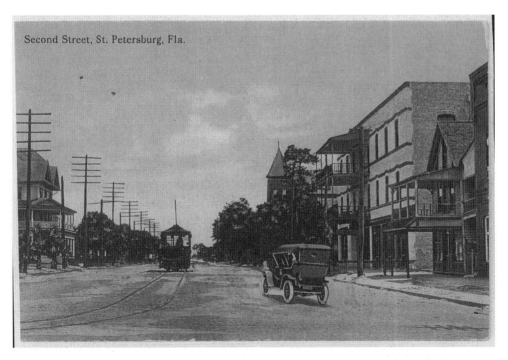

A second trolley postcard showing a trolley on Second Street between the Hollenback Hotel and what was later called the Beverly Hotel, located at Second Street and First Avenue North on the left. Further on the right in the distance can be seen the old Central Hotel. Notice the old car and dirt street.

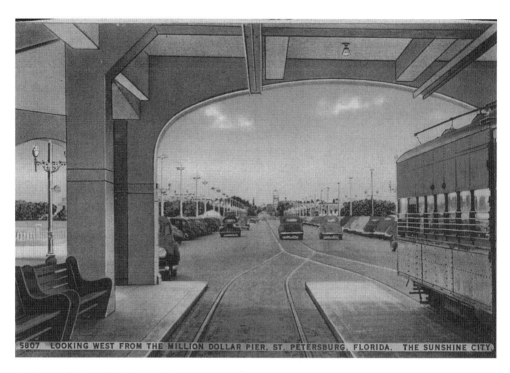

A picture of the trolley inside the Million Dollar Recreation Municipal Pier's building.

The first picture of the port of St. Petersburg shows the ships, people and machinery of the time.

PORT OF ST. PETERSBURG, FLORIDA, "THE SUNSHINE CITY."

A second picture of the port of St. Petersburg shows different ships, equipment and people.

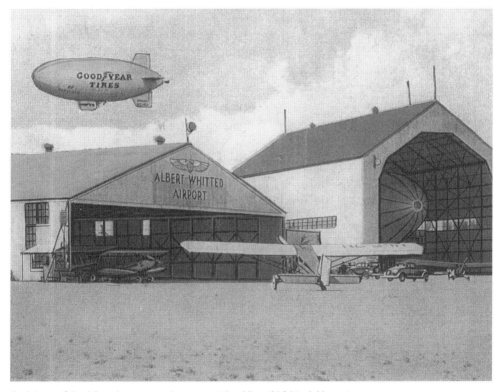

GOODYEAR TIRES

ALBERT WHITTED AIRPORT

A picture of the blimp hangar can be seen at the Albert Whitted Airport.

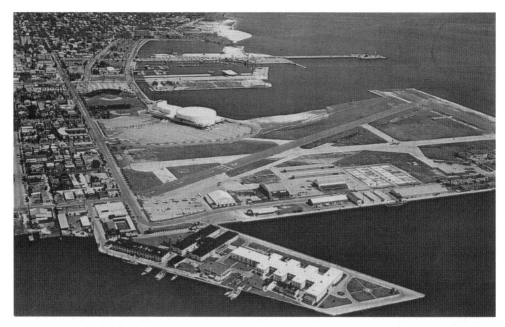

A postcard of the late 1960s shows an aerial view of the Albert Whitted Airport, the St. Petersburg Port and the location of the old U.S. Maritime Facility, which is now the University of South Florida. Other downtown waterfront sites include the Bayfront Center, the Al Lang Field, and two piers into the water. The further top pier is the location of all previous Municipal Piers being rebuilt into the current one while the second extension into the water is Demen's landing, the replacement of the old ACL Pier.

A postcard of the Gandy Bridge tollbooth with a sign on the side stating fifty-five cents for each passenger.

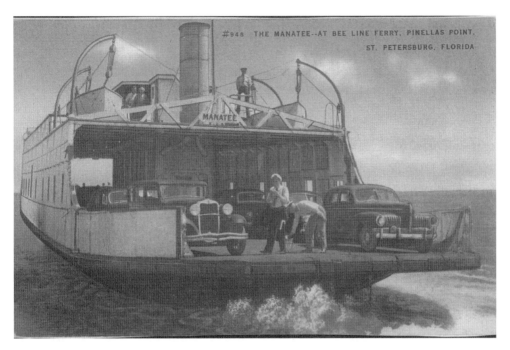

A picture of the *Manatee*, a Bee Line ferry, is on a postcard showing cars being carried across the water to Manatee County from St. Petersburg.

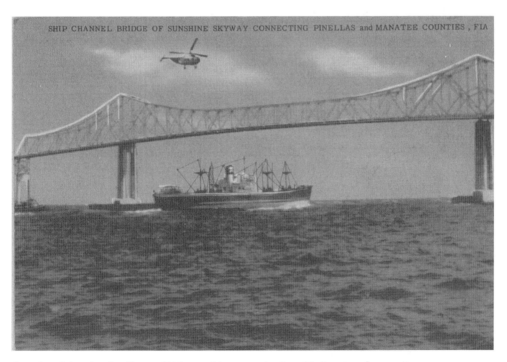

A postcard showing the Skyway Bridge as ships go under it and helicopters fly over it.

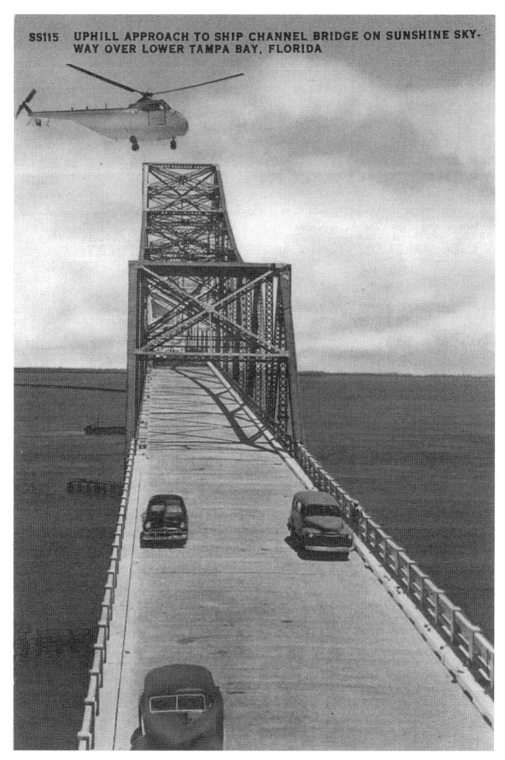

SS115 UPHILL APPROACH TO SHIP CHANNEL BRIDGE ON SUNSHINE SKY-WAY OVER LOWER TAMPA BAY, FLORIDA

A second span of the bridge was opened in 1971. One-way traffic can be seen in this postcard as it became part of two bridges with double lanes.

Bibliography

Alloula, Malek. *The Colonial Harem, Postcards of the Algerian Women*. Minneapolis: University of Minnesota, 1986.

Anderson, Glenn A. Ph.D. Albert Whitted Airport: A Brief History to the 1960s. Unpublished manuscript given to author.

Arsenault, Raymond. *St. Petersburg and the Florida Dream, 1888-1950*. Gainesville: University Press of Florida, 1996.

Baker, Rick. *Mangroves to Major League, A Timeline of St. Petersburg, Florida*. St. Petersburg: Southern Heritage Press, 2000.

Bogdan, Dr. Bob. *Freak Show-Presenting Human Oddities for Amusement and Profit*. The University of Chicago: Chicago, 1988.

———. *Social History*. Iola, WI: Postcard Collector, September 2005.

Davis, F.A. "Progress and Possibilities of St. Petersburg, Florida." Prospectus of St. Petersburg Investment Co., Philadelphia, 1902.

Deese, Alma W. *St. Petersburg, Now and Then*. Charleston, SC: Arcadia Publishers, 1999.

DeQuesada, A.M. *World War II in Tampa Bay*. Charleston, SC: Arcadia Publishers, 1997.

Fuller, Walter. *The People and Their Money*. St. Petersburg: Great Outdoors Publishing Company, 1972.

Grismer, Karl H. *History of St. Petersburg: Historical and Biographical*. St. Petersburg: Tourist News Publishing, 1924.

Homan, L.M. and T. Reilly. *Wings over Florida*. Charleston, SC: Arcadia Publishing, 1999.

Hurley Jr., F.T. *Pass-a-Grille Vignettes, Times Past Tales Remembered*. Pass-a-Grille, FL: Friends of the Gulf Beaches Historical Museum, 1999.

Lowe, James Louis. *Standard Postcard Catalog*. Ridley Park, PA: Deltiologist of America, 1982.

Marth, Del. R., and Martha Marth. *St. Petersburg: Once Upon A Time, Memories of Places and People 1890-1990s*. Branford, FL: Suwannee River Press, 1996.

Mashburn, J.L. *The Artist-Signed Postcard Price Guide, A Comprehensive Reference*. Enka, NC: Colonial House, 1993.

Mellinger, W.M. "Representing Blackness in the White Imagination: Image of Happy Darkeys' in Popular Culture, 1893-1917." *Visual Sociology* 7, no. 3 (1992): 3-21.

Miller, George, and Dorothy Miller. *Picture Postcards in the United States 1893-1918*. New York: Clarkson Potter, 1976.

Reilly, T. "National Airlines: The St. Petersburg Years 1934-1939." *Journal of Airline Pilot* 60, no. 2 (February 1997).

Roberts, L. "Esmond G. Barnhill, 1894-1987." *Florida's Golden Age of Souvenirs, 1890-1930*. Tampa: University Press of Florida, 2001.

Spencer, Donald. *St. Petersburg in Vintage Postcards*. Ormond Beach, FL: Camelot Publishing Company, 2002.

Weaver, B., and R. Weaver. *The Citrus Industry in the Sunshine State*. Charleston, SC: Arcadia Publishers, 1999.

Young, June Hurley. *Florida's Pinellas Peninsula*. St. Petersburg: Southern Heritage Press, 1996.
———. *The Vinoy: Faded Glory Renewed*. St. Petersburg: Partnership Press, 1999.

Ziebold, T.O. PhD. *Descendants of John Constantine Williams, Creator of St. Petersburg, FL*. Largo, FL: Pinellas Genealogy Society, 2003.